1

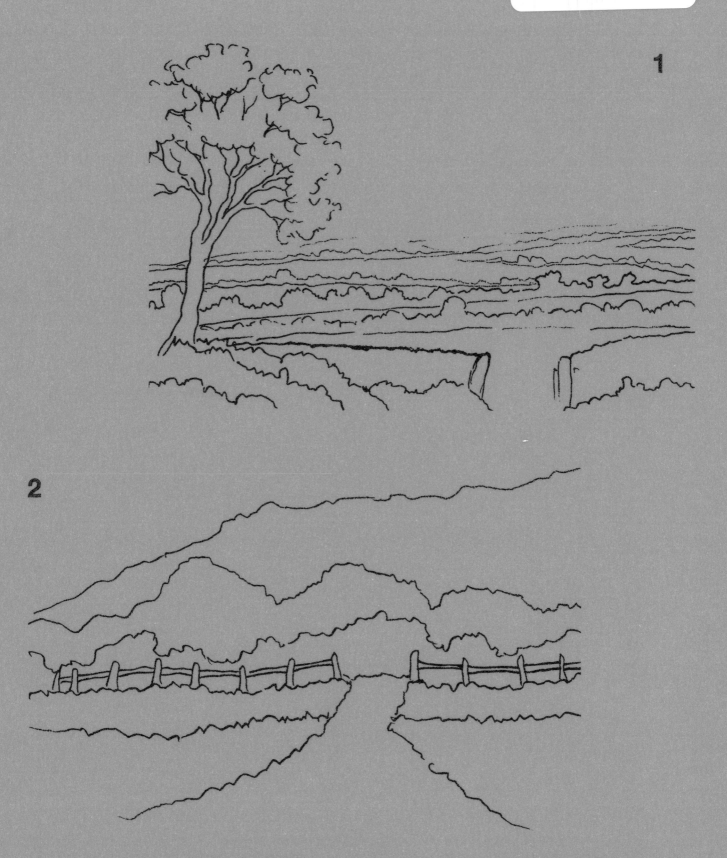

2

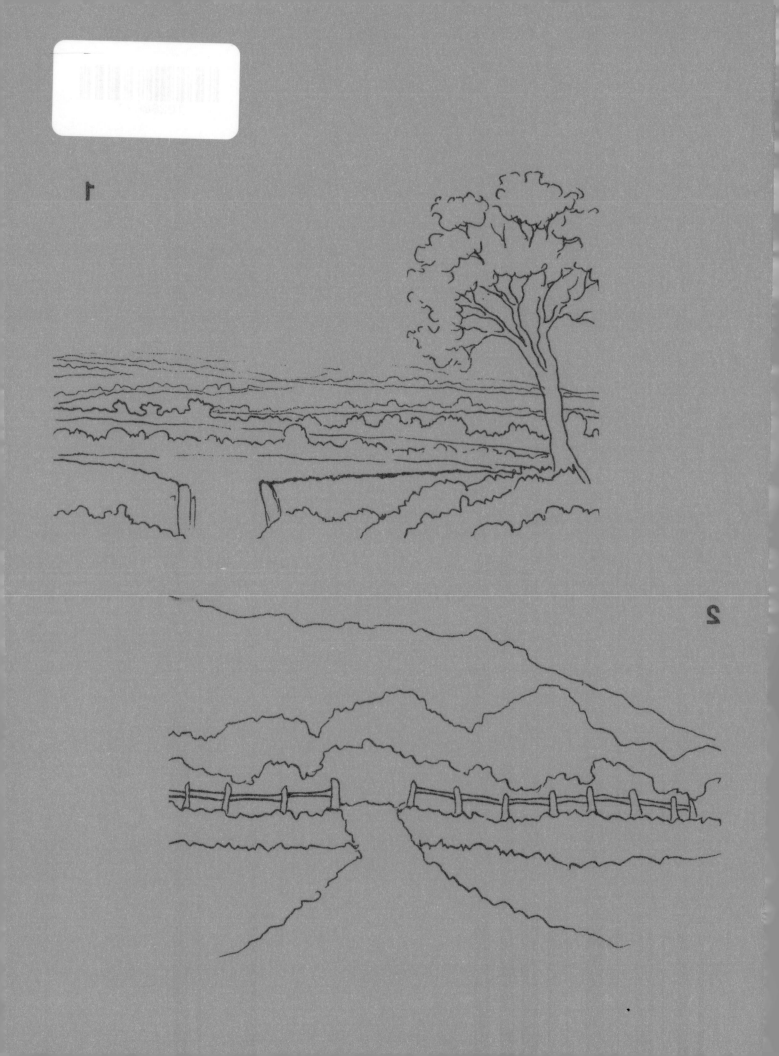

1

2

3

4

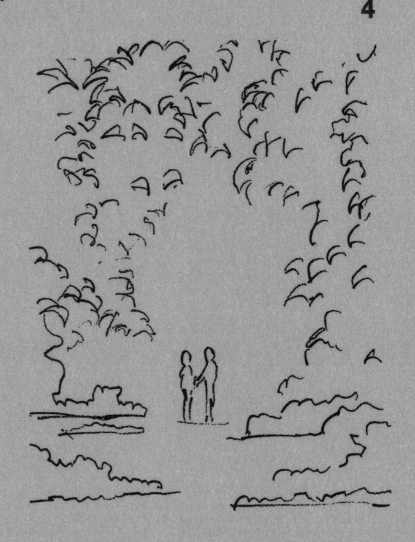

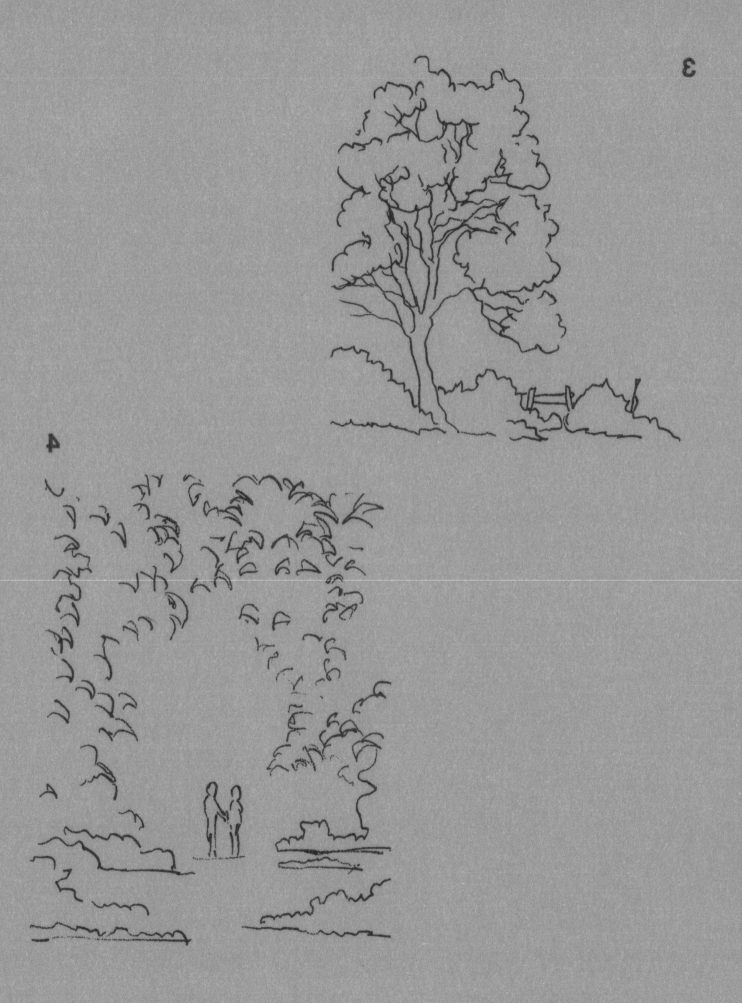

3

4

5

6

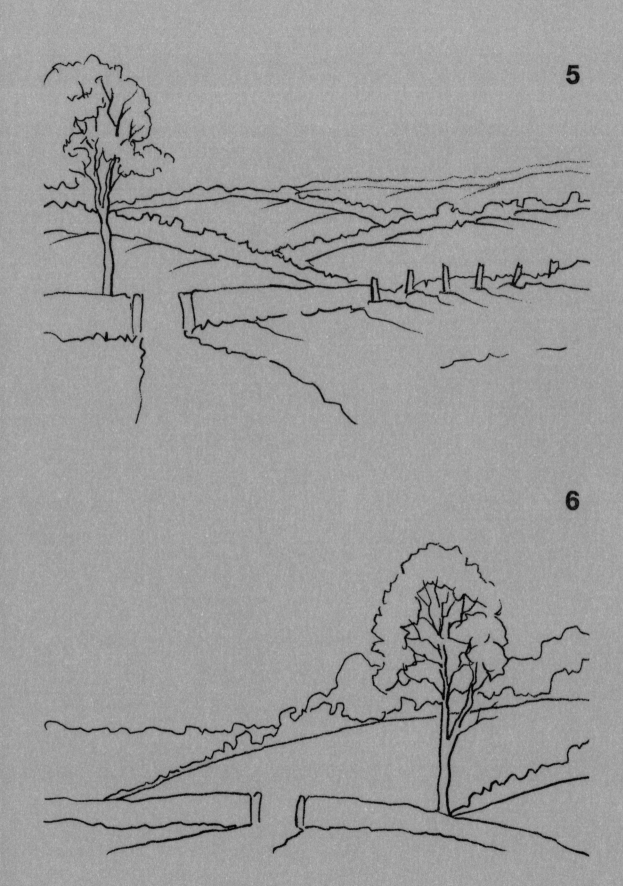

5

6

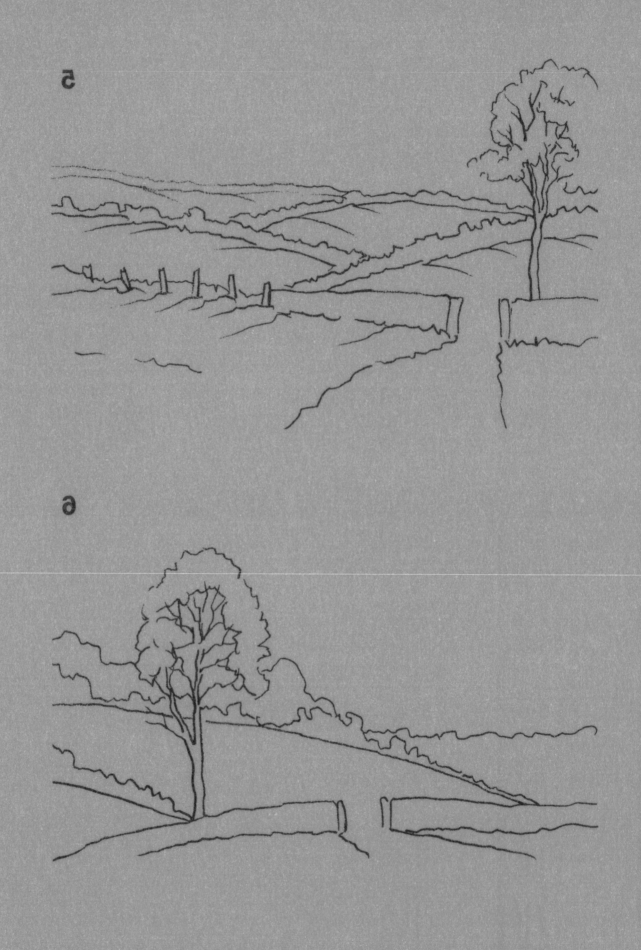

7

8

9

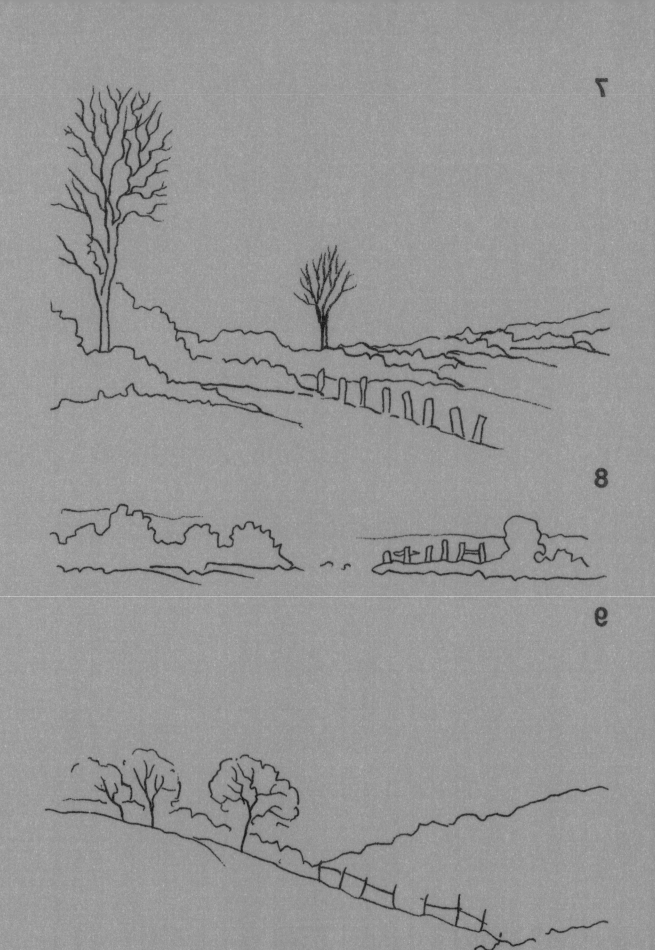

7

8

9

10

11

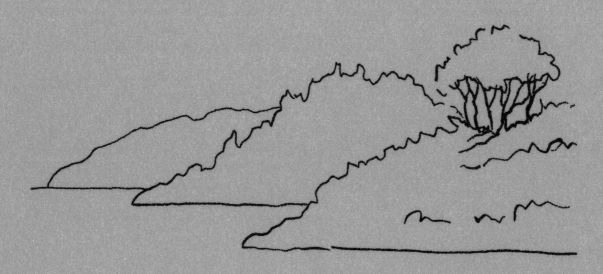

12

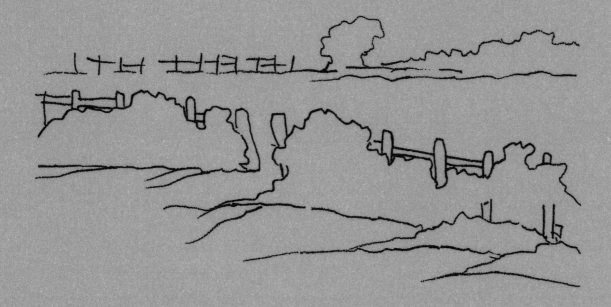

13

14

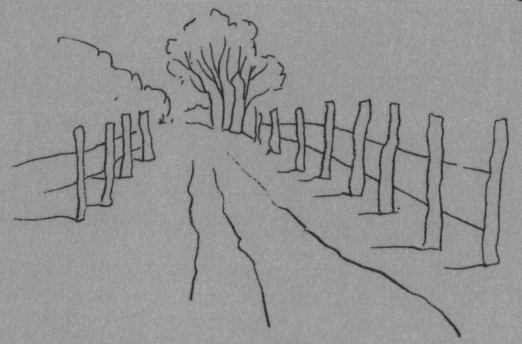

15

16

15

16

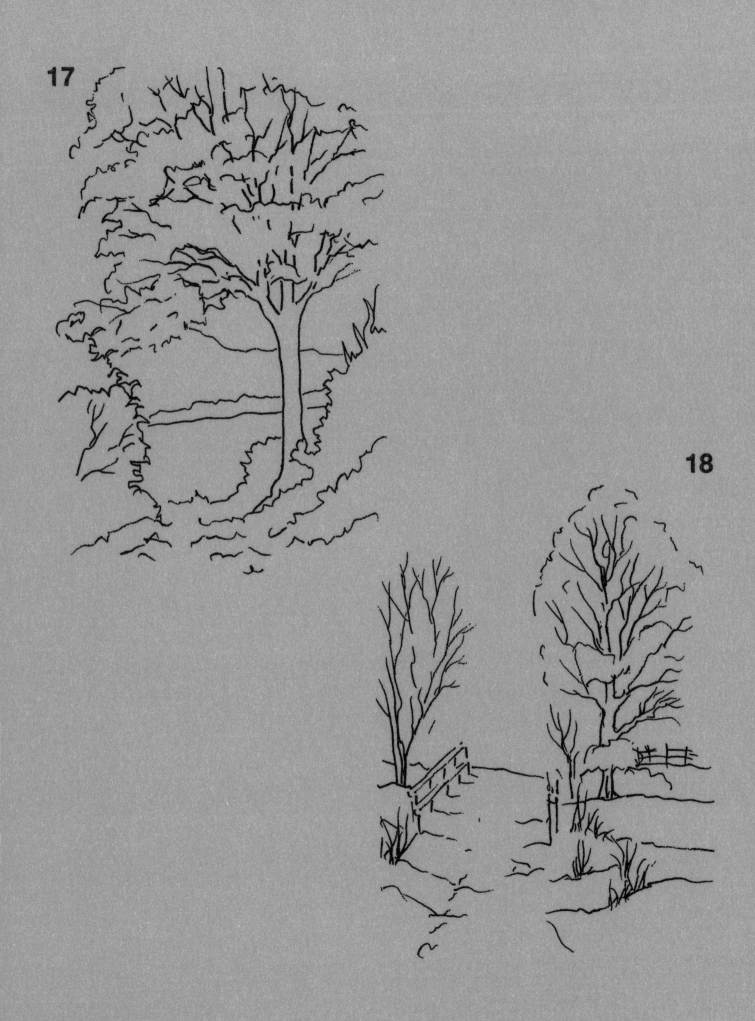

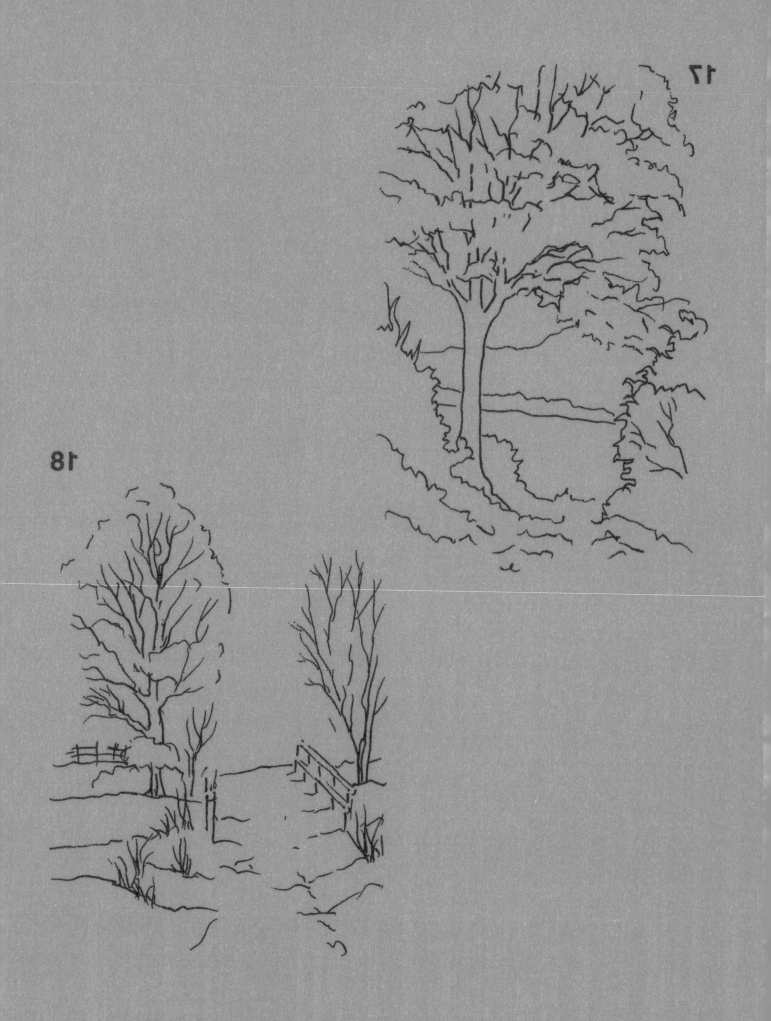

17

18

19

20

19

20

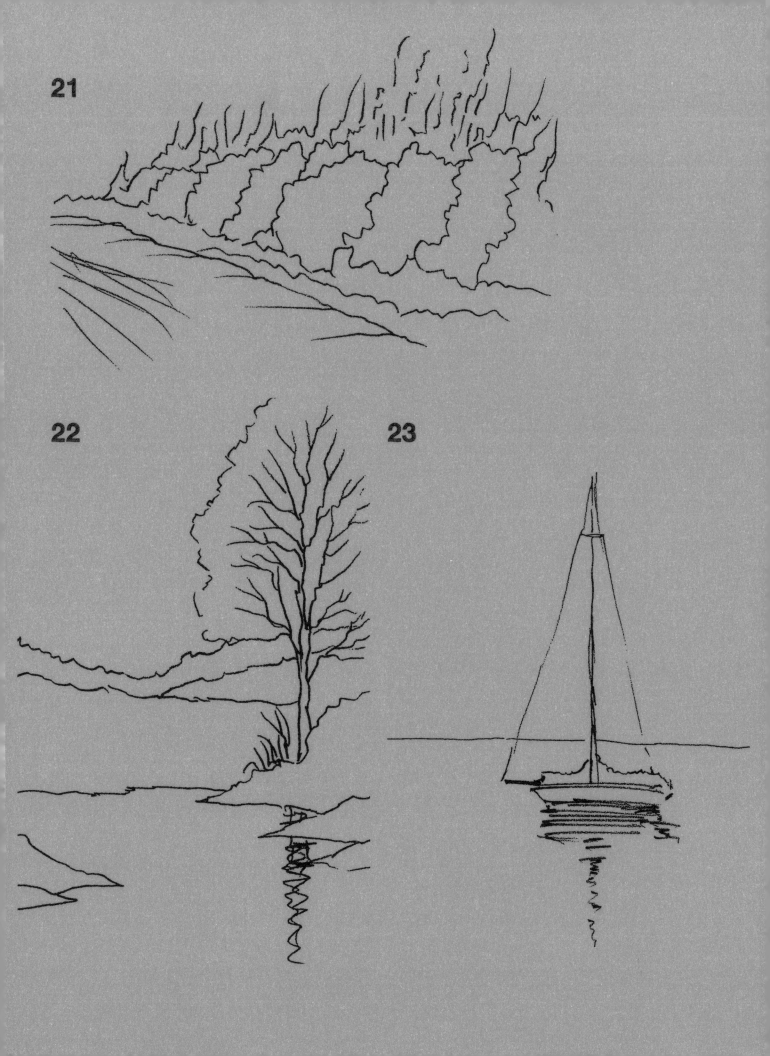

21

22

23

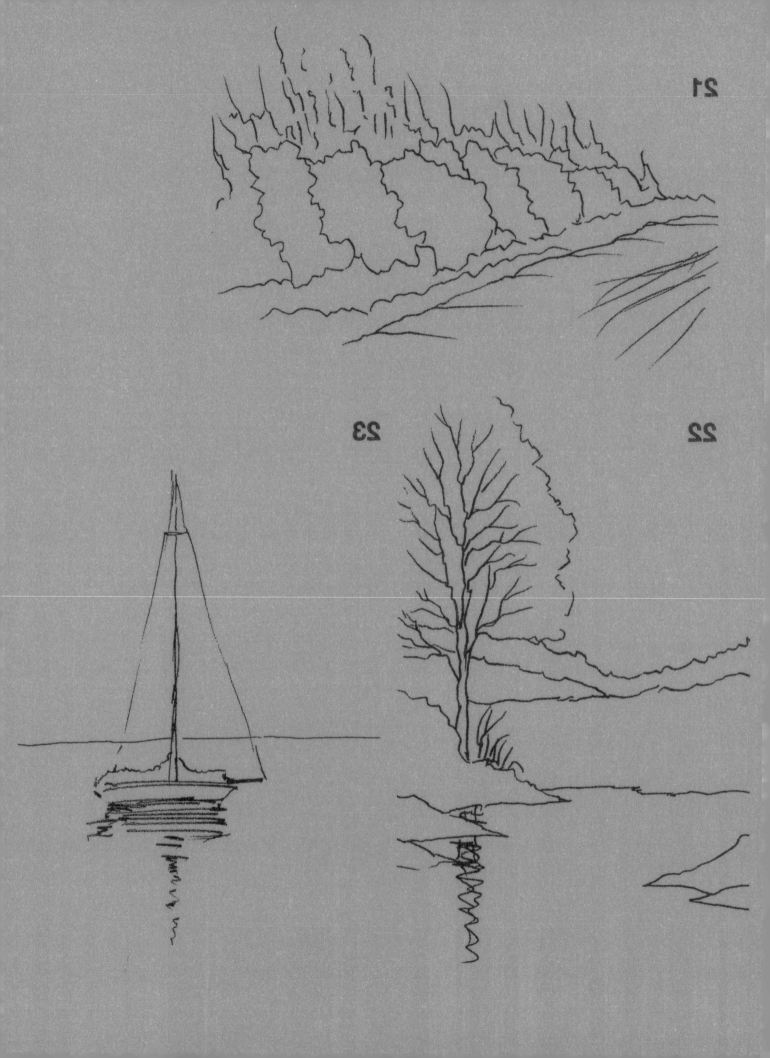

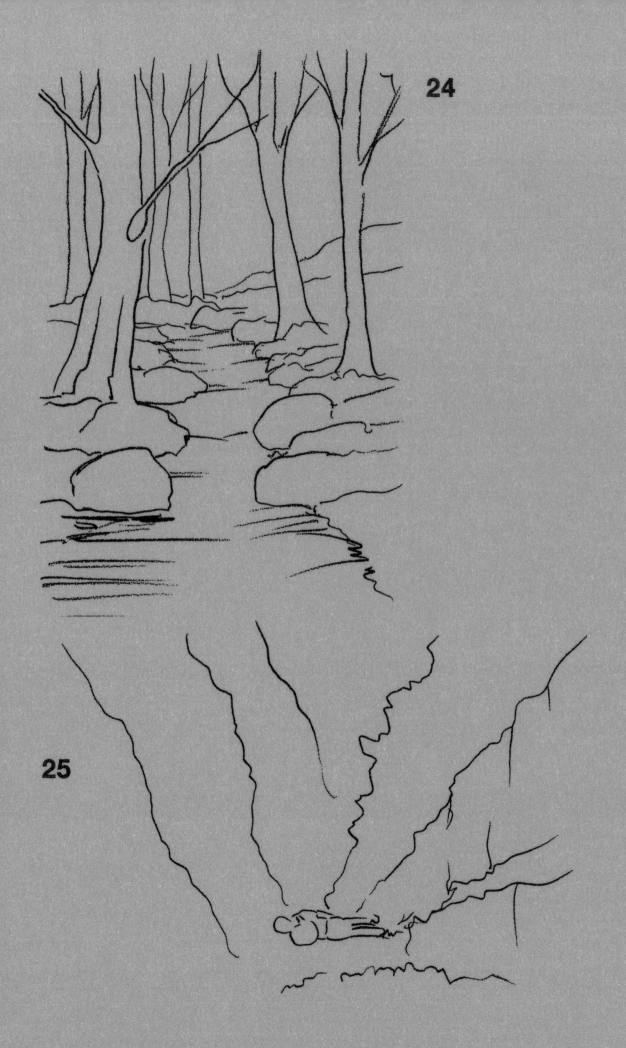

24

25

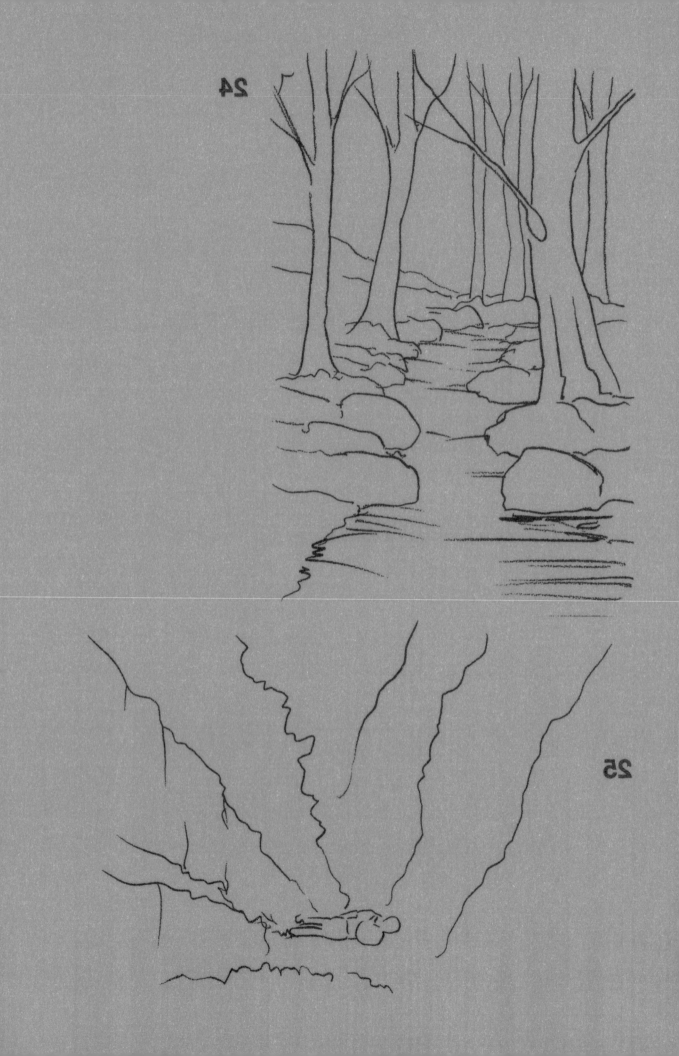

26

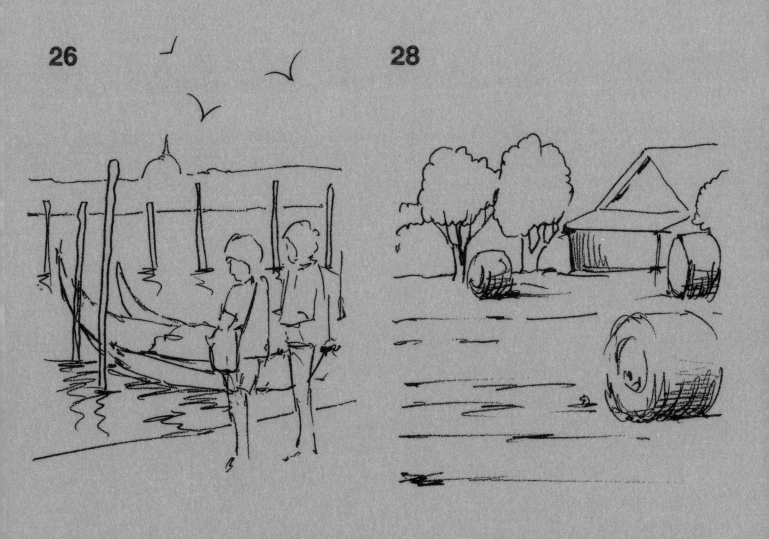

28

27

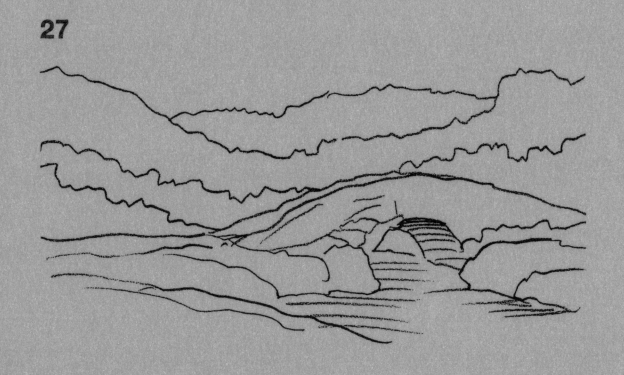

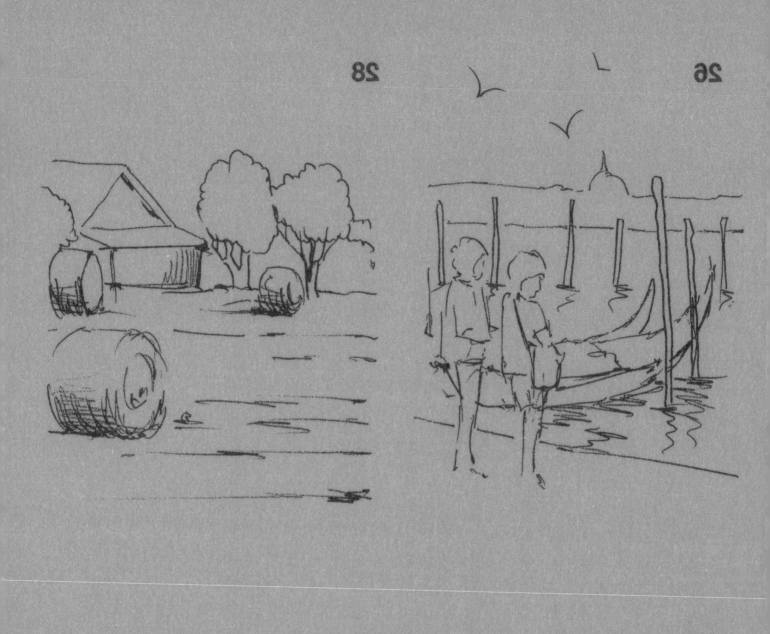

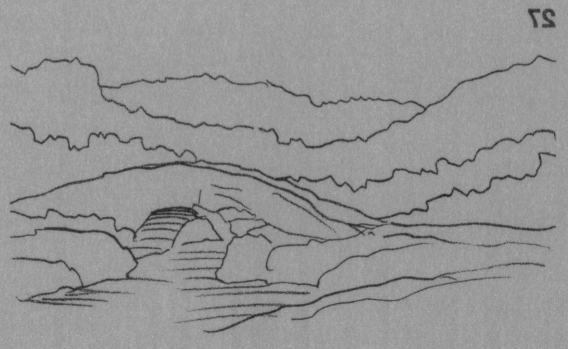

29

30

33

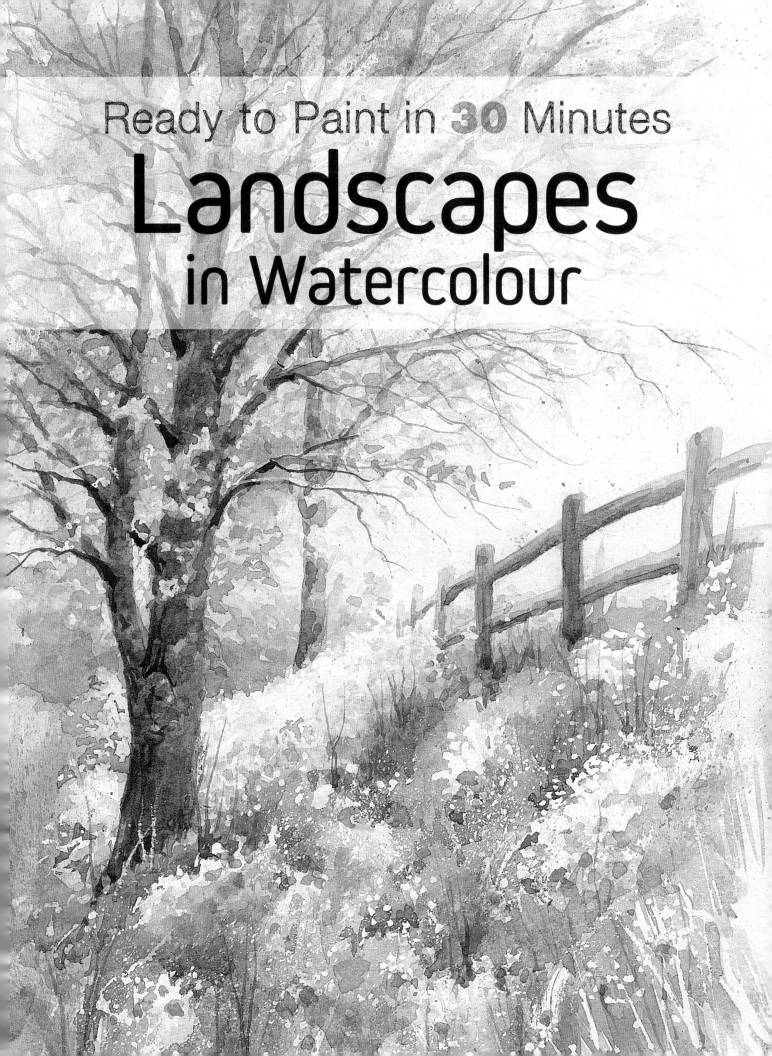

Ready to Paint in **30** Minutes
Landscapes
in Watercolour

Dedication
To my three wonderful daughters: Helen, Rachel and Rebecca.

DAVE WOOLASS

Ready to Paint in 30 minutes
Landscapes
in Watercolour
Dave Woolass

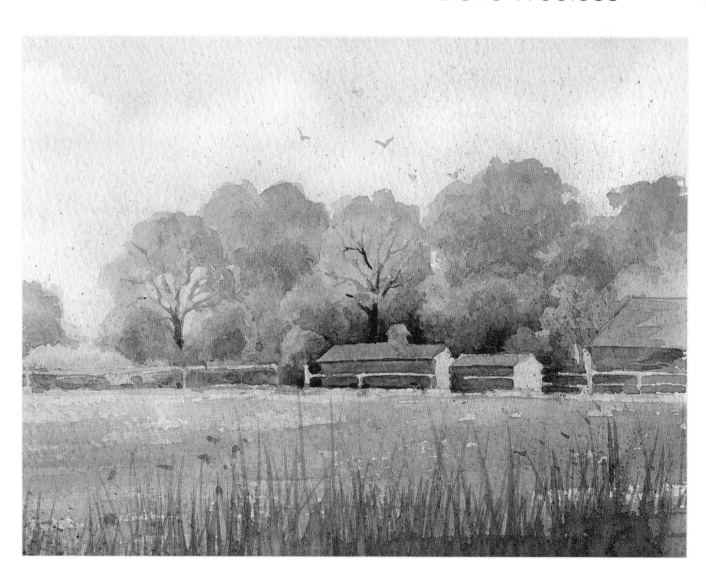

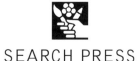

SEARCH PRESS

First published in 2018

Search Press Limited
Wellwood, North Farm Road,
Tunbridge Wells, Kent TN2 3DR

Reprinted 2018, 2020, 2022, 2023

ISBN: 978-1-78221-414-4

The Publishers and author can accept no responsibility for
any consequences arising from the information, advice or
instructions given in this publication.

Suppliers
If you have any difficulty obtaining any of the materials
and equipment mentioned in this book, please visit the
Search Press website: www.searchpress.com

Acknowledgements
To my partner, Joan, who helped me with the writing of
the book.

To Beth Harwood, my editor, who understood what I was
trying to convey.

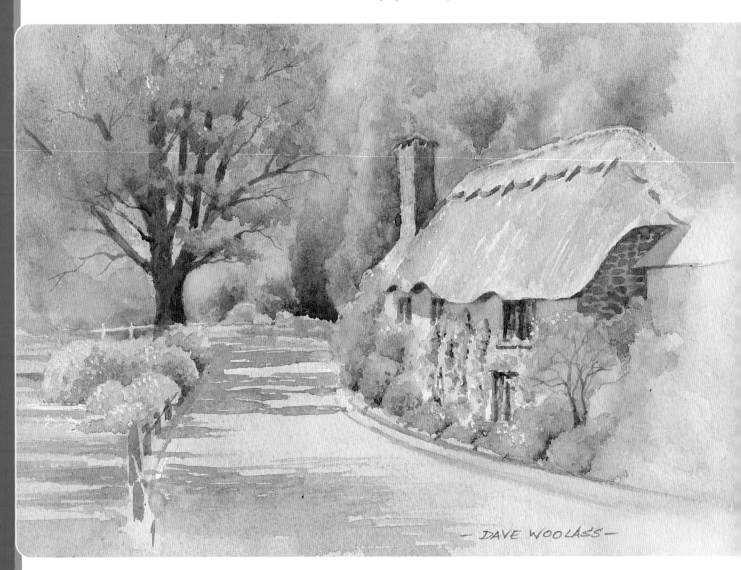

— DAVE WOOLASS —

CONTENTS

INTRODUCTION

If you are excited by watercolour painting, then you can rest assured that you already have the most important attribute required to create beautiful landscapes in thirty minutes!

When I was planning this book, I had to consider how I could help watercolour artists develop their skills, whatever their stage of development. Most of the time it is difficult for artists like me to instruct others in the art of watercolour painting because much of what we do is instinctive, and most of the time, we're unaware of why we do what we do whilst creating a painting. It just feels right: a little bit of yellow here, a blending of colours there and a good contrast of lights and darks in the right places… There is no magic recipe for us; it's merely a dash of experience and a great deal of passion and personal enjoyment in the creation of our paintings. With this in mind, I concluded that the best way to help watercolour painters develop – no matter what their starting point – was to set out within the pages of this book some of my own experience and instinctive flair, conveyed in the form of simple techniques and processes, free of rigid rules. You will find each of my explanations of technique and process has been broken down into very simple steps that will, hopefully, smooth your path towards the sheer enjoyment of creating a piece of art that will give pleasure to yourself and others.

I have observed over the years that a number of art instruction books seek to set out seemingly rigid rules that unfortunately often inhibit, rather than facilitate, the mastery of watercolour painting. In my experience, there is only one rule to realistic watercolour landscape painting and that is the rule of perspective. As for the rest, my advice would be: if a particular, traditional rule helps you gain confidence in watercolour, then by all means seek to master it and use it, but if the rule mars your enjoyment because you can't seem to make headway with it, then simplify things for yourself by disregarding it, and follow your instinct instead.

Painting is meant to be a pleasure in your life, free of angst, so therefore allow me to introduce to you the joys of watercolour painting!

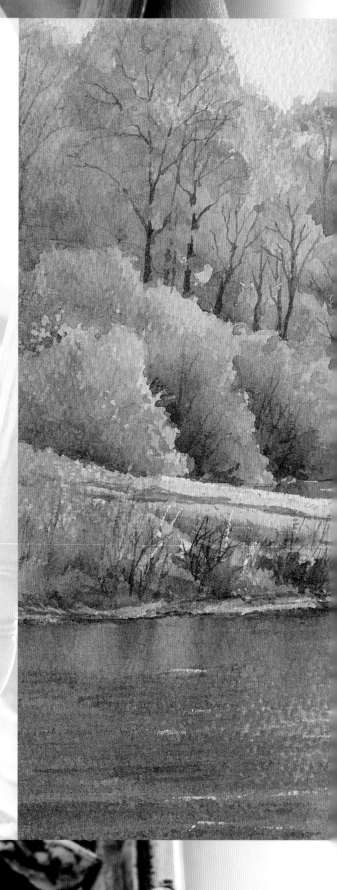

Riverside Reflections
36 x 27cm (14¼ x 10¾in)

BASIC PAINTING EQUIPMENT

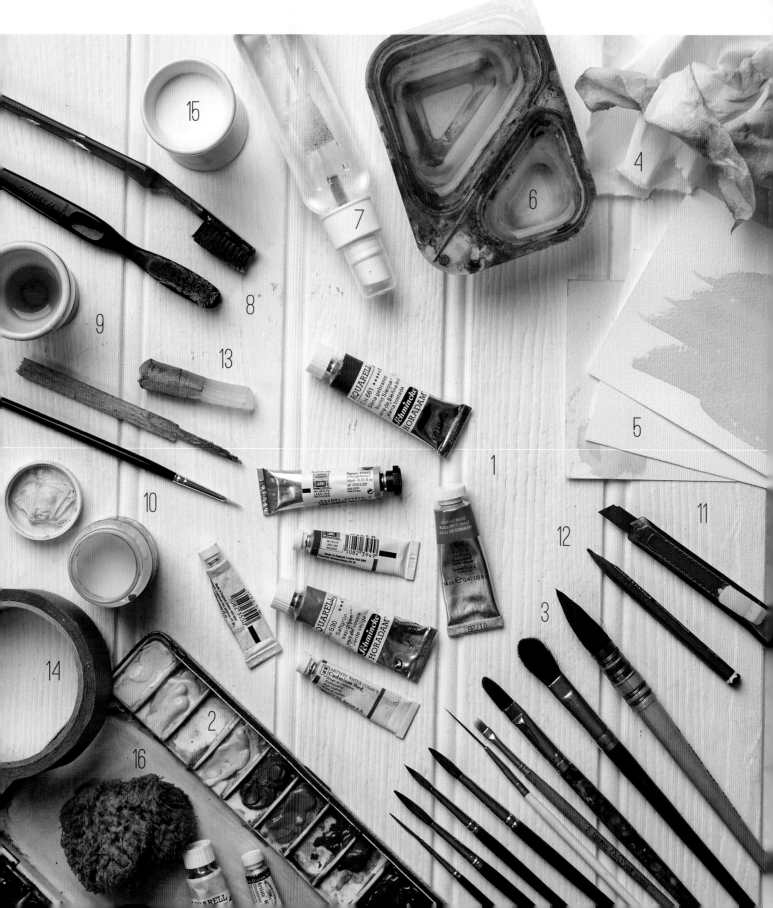

The materials that you use for watercolour are a matter of personal choice: the more experience you gain, the more the medium will guide you towards the equipment that will suit you best. In the meantime, and to help you specifically with the exercises set out in this book, I suggest that you use the following, which should be of the best quality that you can afford.

1 Watercolour paints Watercolours are bought either in tubes or as pans; I prefer tubes as I can use just the amount I need. However, for beginners, it is usually better to use the pans as it helps you with the right mix of colour with water.

2 Palette Various styles of palette are available for watercolour artists. When choosing a palette, look for one with small areas for loading your colour and large areas for mixing your washes.

3 Brushes You do not need too many brushes when starting out. The main brushes you will need are: large, medium and small wash brushes: 12mm, 25mm or 37mm (½in, 1in or 1½in); size 8 round; size 6 round and a rigger – a round brush with much longer bristles – in size 1 or 2. Watercolour brushes are available with various types of bristle, but I recommend you go for the more expensive sable-hair brushes as they hold the colour and water better.

4 Painting rag A rag with a blend of wood and cotton pulp fibres facilitates good lift-off, blending and softening techniques. It should always be used damp with watercolour. My preferred rag is lint-free and unlike kitchen towels, it is also strong and can be reused.

5 Paper Watercolour paper is available in various weights and textures. Using water on paper tends to lead to the paper buckling; the thicker your paper, the less chance of 'buckling'. There are lots of manufacturers of artists' paper out there and each paper will produce different results, but if you try a number of different types you will eventually find the one that suits you. For the studies in this book, I recommend Bockingford 300gsm (140lb) NOT paper.

6 Water container I use an old double yogurt container. This provides two areas for water, the large one used solely for brush cleaning leaving the other for mixing colours.

7 Spray bottle Before you start to paint, spray your paints with clean water to soften them. This helps with mixing and creating special effects within your washes. Spraying clean water into your wash helps the flow of colours. Using a very fine spray on wet paint can also slow the drying time, which is useful when adding extra colour.

8 Toothbrushes Great for creating a splatter effect in your painting. Try to use the ones with straight bristles, and always load the paint onto the side of the bristles.

9 Dish-washing liquid Adding a little detergent to your colours creates some amazing effects and unusual textures. It is very important however, to make sure that your brushes are thoroughly cleaned afterwards.

10 Masking fluid and applicators Masking fluid can be drawn, splattered, dabbed or flicked onto any dry painting surface (do not apply to a wet or damp surface) to protect small, relatively complex shapes and light in a painting. There are several tools you can use to apply masking fluid e.g. a small piece of bamboo, the bottom of your brush handle, a watercolour brush that has been dipped in dish-washing liquid, a ruling pen, a cocktail stick and many more.

11 Craft knife This is used for creating highlights and detail lights with the scratch-out technique (see page 69).

12 Drawing pencil A couple of good-quality graphite pencils are needed for making initial sketches: grades HB and 2B.

13 Candle wax Using a wax crayon or candle to draw on the paper creates a barrier on the paper that stops the paint from sticking to its surface, allowing for special effects and unique textures in your work.

14 Adhesive tape Ordinary masking tape or Tesa tape (a brown adhesive tape similar to masking tape) is ideal for adhering small sheets of paper to your board. For larger paintings, a stronger tape (gummed paper tape) may be used.

15 Table salt Sprinkled into wet (but not shiny) paint, this is fantastic for creating textured effects which will vary depending on the type of salt and the wetness of the paper.

16 Natural sponge These can be dipped in the paint and dabbed on the surface, transferring the texture of the sponge to the paper. Sponge can be used dry or damp to give a light and airy look to foliage, for example.

In addition to the items pictured, you will also find the following equipment useful:

Board A board on which to mount your watercolour paper is essential. Any size board will do but it must be slightly larger than the piece of watercolour paper you are using. A light, firm plyboard, about 1cm (½in) thick, is suitable for use with gum tape and drawing pins. MDF boards will also work, but are much heavier.

Easel You don't have to have an easel, but having one makes life much easier when painting outdoors. You can use a table easel or a floor easel; whichever you use, it is important that the easel allows you to adjust the angle of the painting surface; that is, it allows you to work flat or at an angle. When working on a table indoors, it is also advisable to use an easel that can support the adjustment of the painting surface. The simplest way to paint without an easel is to lay your board on a table, with something small (like a book) under the end furthest away from you to tilt it towards you.

COLOUR MIXING

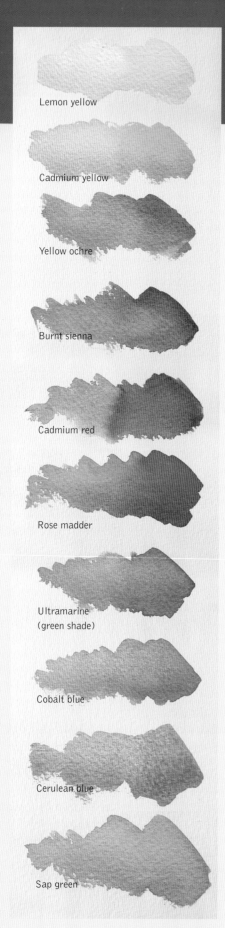

Lemon yellow

Cadmium yellow

Yellow ochre

Burnt sienna

Cadmium red

Rose madder

Ultramarine
(green shade)

Cobalt blue

Cerulean blue

Sap green

A huge number of books have been devoted to the subject of colour. I do not intend to replicate this plethora of information on these pages, but I do suggest that you read up on the subject later. It will aid the progression of your painting skills if you can fully understand the terms relating to colour; to this end, I shall explain them briefly on these pages.

YOUR PAINTS

There are two types of watercolour paints: artists' quality and students' quality. The difference between them is – as the term would suggest – the quality, and inherently the cost difference between the two. The best-quality paints are the artists' quality, which are more expensive – they contain more pigment and less, if any, filler than students' quality paints do.

YOUR COLOUR PALETTE

For most landscape work I recommend the colours on the left, which constitute a good basic palette, and which can be supplemented with additional colours.

You may find your physical palette works better for you if cool colours are grouped on one side of the palette and warm colours on the other. Each group of colours can then be graded from light to dark. This will help you to locate colours more easily as you paint.

COLOUR TEMPERATURE

When we refer to a colour as warm, cool, hot or cold, we are referring to a colour's temperature. Some colours are seen to be quite hot and others very cold, but most colours are either warm or cool. Reds, oranges, yellows and violets are all in the warm category; blues and greens are usually classified as cool.

However, colour temperature is more complicated than that. Each colour category has its hot to cold temperatures. Within the reds, you will find hues that are brilliant, such as cadmium red – a hot red, and on the other end of the scale, red can also be a cool colour, such as rose madder. If placed side by side, one can see a striking difference in the temperature of these colours, as the cool red will contain blue.

MIXING COLOURS

When mixing colours, it important how you begin. Apply water to a large area of the palette, adding a small amount of the colour you require, and mix with a brush. If you need to intensify the colour, add more pigment; if you need to weaken the colour, add more water.

After each mix you make, it is advisable to test the colour on a separate test paper to see what it will look like on the painting: the colour intensity will appear different in the palette from on the paper.

UNDERSTANDING COLOUR TERMINOLOGY

Hue is the term used to name a colour – red, yellow, blue and so on.

Value refers to the lightness or darkness of a colour.

Intensity is the saturation, strength or purity of the colour.

Colour temperature is the warmth or coolness of a colour.

Clumber Park Church
52.5 x 34cm (20¾ x 13½in)

Colourful greys

YOU WILL NEED

Paint colours: cobalt blue, ultramarine (green shade), rose madder, sap green, cadmium yellow, cadmium red, burnt sienna

Brushes: small wash brush, medium wash brush, size 4 round brush, filbert, size 2 round brush

Other: rag, tracing number 1

When you are looking at landscapes, most of the colours you see are an assortment of greens, blues and a selection of greys.

To make a series of useful, colourful greys without adding black, which would dull your painting, mix burnt sienna (a neutral orange-brown) with a warm blue such as ultramarine (green shade) or cerulean blue – a cooler blue. Any grey can be adjusted with the addition of a touch of either (or both) of the pure colours, and tinted lighter using water or white pigment.

PUTTING IT INTO PRACTICE

In this study, ultramarine (green shade), rose madder and sap green have been used as the grey mix with brighter pigments added in. The diagram below shows the myriad colourful grey mixes used to create the scene.

If you would like to recreate the scene, start with a graded-wash sky (see pages 26–27) in cobalt blue, with clouds lifted out using a damp rag (see inset and page 13). Take up some more cobalt blue on the rag to dab in some shadows on the clouds, then follow the steps detailed here.

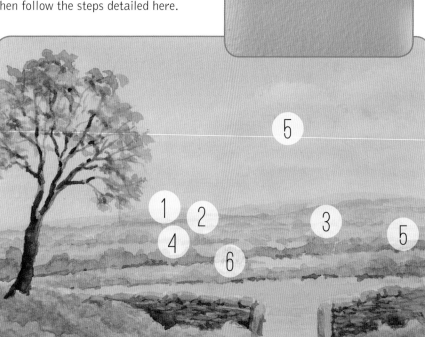

Granulation

Ultramarine (green shade) is a granulating pigment which means that it does not absorb easily into paper, so you cannot expect it to produce smooth washes. However, you can use the granulation – as the pigment settles into the paper – to represent texture.

1 **Ultramarine (green shade), rose madder and sap green: purple-grey** Use this mix to draw in the shapes of the background hills.

2 **Ultramarine (green shade), rose madder, sap green plus cadmium yellow: yellow-grey** Paint in a broken line directly beneath the first line of hills. Paint in a first, distant hedgerow in this same yellow-grey mix, and soften both new lines with a damp rag.

3 **Ultramarine (green shade), rose madder, sap green, cadmium yellow plus cobalt blue: green-grey** Add more cadmium yellow to the mix and introduce some cobalt blue for a green-grey mix to wash into some of the hillsides. Add more cobalt blue and cadmium yellow to this mix, and paint in another hedgerow.

4 **Sap green, cadmium yellow and cadmium red: brown-grey** Lay a weak wash of sap green into the land area first; then into that bring a weak orange mix of cadmium red and yellow so the colour just comes through. The brown tones will represent buildings later on.

Dot in the two foremost hedgerows in loose diagonal lines, using mixes of sap green with cobalt blue and burnt sienna for interest.

5 **Ultramarine (green shade), rose madder and sap green: purple-grey** Dab the purple-grey mix, wet-into-wet, into the shadows of the clouds and the hedgerows.

6 **Rose madder, ultramarine (green shade) and touch of sap green: reddish-grey** Use this rust-grey to dot in the bottoms of the hedgerows.

7 Ultramarine (green shade) and burnt sienna: blue-grey Use this mix to create the shape of a dry-stone wall in the foreground. The foliage in front of the wall is filled in in a mix of sap green with ultramarine (green shade).

Leave a gap in the centre of the wall for a gate, then, in a mix of sap green and cadmium yellow, fill in the field behind the wall. Paint in sap green as a shadow colour at the base of the gateway. Glaze the wall with rose madder, then a second layer of cadmium yellow and cadmium red mix.

8 Ultramarine (green shade) and burnt sienna: dark grey Take up this grey on a size 2 rigger to paint in the large tree on the left of the scene. Smudge the ends of the branches to suggest tiny twigs. Use the same mix to paint in the gateposts on either side of the gap in the wall.

9 Ultramarine (green shade), rose madder and sap green: purple-grey Pick out the individual stones in the dry-stone wall.

10 Sap green, ultramarine (green shade) and rose madder): green-grey Dab and twist in the first layer of foliage on the tree, using a filbert (see page 51).

11 Paint in negative shapes (see page 15) over the foliage in the foreground in front of the wall using cobalt blue; the greens and yellows in the foliage will make a colourful grey when blended with the blue. Paint cobalt blue into the wall on both sides and dot a little into the foremost hedgerow. Then dab and twist cobalt blue into the foliage of the tree (see page 51).

12 Ultramarine (green shade), rose madder and sap green: purple-grey (stronger mix) With size 4 and size 2 round brushes. pick out the shapes of the bricks in the wall.

13 Use the size 4 brush to fill in the details on the tree trunk in the mix from step 12. Dampen the size 2 and use this to blend the colours. Leave some areas on the tree light to create a three-dimensional effect. Dab and twist a darker mix of the same grey into the foliage (see page 51).

14 Complete the scene by sweeping cadmium yellow into the field behind the wall, then dotting rose madder, on the rag, into the tree, the foliage and the hedgerows to soften them.

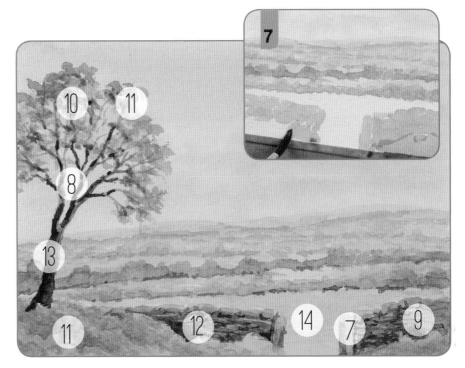

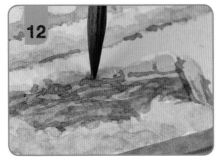

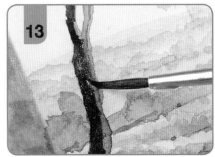

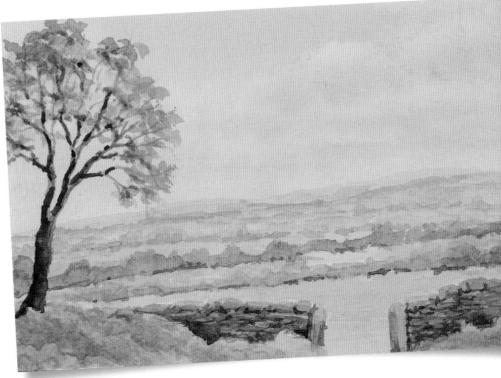

Mixing greens

Mixing just the right greens has always been a problem for many landscape artists. We know from our school days that by mixing a yellow and a blue together, we get the colour known as green. However, the different greens we see in a landscape show us that there is more than one type or shade of green. Getting the right green colour depends upon the warmth of the components – blue and yellow – as well as any other colours that might be added.

YOU WILL NEED

Paint colours: sap green, ultramarine (green shade), cerulean blue, lemon yellow, ultramarine (green shade), rose madder, cobalt blue, cadmium yellow, cadmium red

Brushes: size 4 round, size 6 round, large wash brush, size 2 rigger

Other: craft knife, rag, tracing number 2

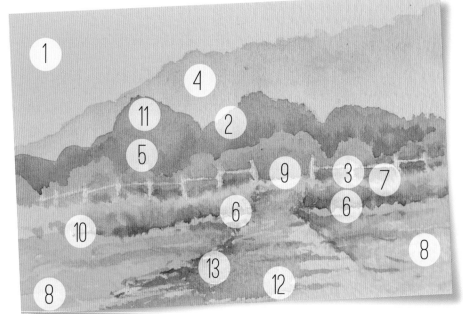

1 Lay a graded wash (see page 26) in sap green using a large wash brush.

2 Mix sap green with ultramarine (green shade), and, with a size 6 round brush, create a row of trees in the upper half of the paper with this darker mix, working wet-in-wet. Soften the bottom edge of the foliage line with a damp rag, then allow to dry.

3 With a craft knife, scratch vertically into the bottom edge of the hedge to show where the edge of the field lies and to lay in the shape of the fenceposts. Then scratch horizontally to join up the posts.

4 Take up the size 4 round brush. With a mix of cerulean blue and lemon yellow, scribble in the profiles of trees in the background, behind the hedgerow. Clean your brush, then soften any hard edges.

5 Use the same blue-green mix over the green hedgerow areas, painting a negative shape to suggest a second row of hedges in front of the first. Glaze over the negative shape painting with purple – ultramarine (green shade) and rose madder – and allow to blend wet-in-wet.

6 Change the green mix to cobalt blue and cadmium yellow, with a touch of cadmium red. With the size 2 rigger, work greenery along the foreground, following the scratched-out fence lines. Suggest the outlines of the path leading from the gap in the fence, and establish the darker edges of the path, wetting and softening the mix as you go along. Define the grass on either side of the path with a dry-brush technique (see page 53), softened with a damp brush.

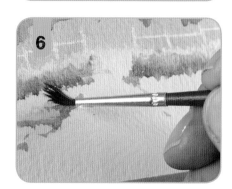

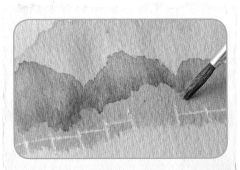

Negative shapes

When we look at anything, we naturally tend to see the objects, rather than the space between and around them. It's very important to learn to observe the space around any object. This space is known as negative space. The shape of the space around the object is as important as the shape of the object itself. If you depict both negative and positive shapes correctly, your painting will be in proportion.

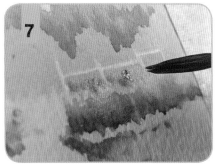

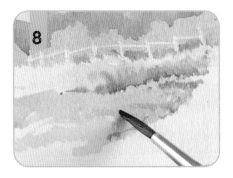

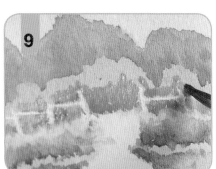

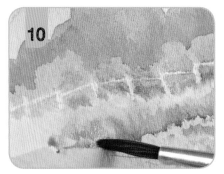

7 Switch back to the size 4 round brush; paint with water between the fenceposts, then, with the cobalt blue–cadmium yellow mix, fill in the spaces, wet-in-wet.

8 With a yellow-green mix of cadmium yellow and cobalt blue, fill in the grass area on the left of the path in the foreground. Repeat on the right side of the path, applying a dry brush technique. Add more cadmium yellow to the mix and use this to highlight the top edge of the grass area under the fence line. Then wash in a little yellow along the front of your painting, in the bottom left and right corners.

9 Mix lemon yellow with touch of cadmium red and some cerulean blue. Fill in the bushes directly behind the fence line in negative shading, and soften with a damp brush.

10 Add a little more cadmium red to brown the green from step 9 (see 'Natural greens', right); use the mix to fill in the spaces in the fence line and work into the rear bushes. Use the same green-brown mix on the edges of the path to fill in the darker areas in the grass.

11 Return to the yellow-green mix from step 8 (cadmium yellow and cobalt blue); use it as a glaze to enhance some of the background bushes and bring out the foliage colours.

12 Use a mix of cadmium red and cadmium yellow to fill in the path, usng loose horizontal strokes. Strengthen the mix and lay in a few darker red details along the left edge as shadow.

13 Finally, go back over the left edge of the path with a purple mix of ultramarine (green shade) and rose madder on the rigger to drop in some last fine details.

Natural greens

Our brains are conditioned to see foliage as green, and our eyes are acutely sensitive to this hue. Painting natural greens can thus be tricky.

Trees and grasses are often less green than you might think; there are often hints of red, brown or even purple in them. Study your subject closely and notice the different greens in the trees, shrubs, grasses and bushes.

If we find that a green mix is too bright, we can alter it by adding various colours to bronze or brown the mix, as in step 10 here. Alternatively, we can brighten the tint with added white or water, or add a lighter colour such as yellow to tint and weaken the mix.

Glazing

Over the centuries, artists have used glazing as a means of creating colours that are richer than would be possible by simply mixing paint on the palette. Glazing is produced by painting a thin layer of watercolour wash over a dried colour wash, and is a great way of building up distinct layers of pure colour that work with other colours underneath them, rather than concealing them. It can also help you correct tonal values or reduce excessive colour contrast.

In order to sample the effect of glazing one colour over another colour, you should create a colour glaze chart. To glaze a layer, apply a very thin layer of colour over a dry background. You will then be able to modify the tonal value as well as the colour of the background layer.

How do you know if a colour is suitable for glazing?

It is best to test the paint you wish to use for glazing before applying it, as there are significant variations in transparency for the same pigment across different manufacturers.

CREATING A COLOUR GLAZE CHART

YOU WILL NEED
Paint colours: lemon yellow, cadmium yellow, rose madder, cadmium red, cerulean blue, ultramarine (green shade)
Brushes: small wash brush

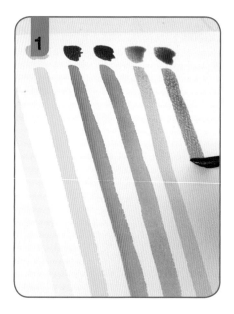
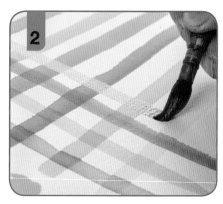
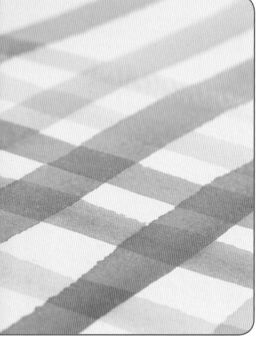

1 To create your colour glaze chart, begin by mixing a wash of each of the colours in your palette. Paint a colour reference spot with the first colour, then below that paint a long flat wash of that colour. For the purposes of this exercise, lay the colours down in this order: lemon yellow, cadmium yellow, rose madder, cadmium red, cerulean blue, then ultramarine (green shade). Allow the paints to dry completely.

2 Turn the paper ninety degrees and repeat the process; ensure that the flat wash of each colour goes over each of the first washes. You will see that new colours have been created at each intersection. This effect can be used to create some very subtle colour changes in your painting.

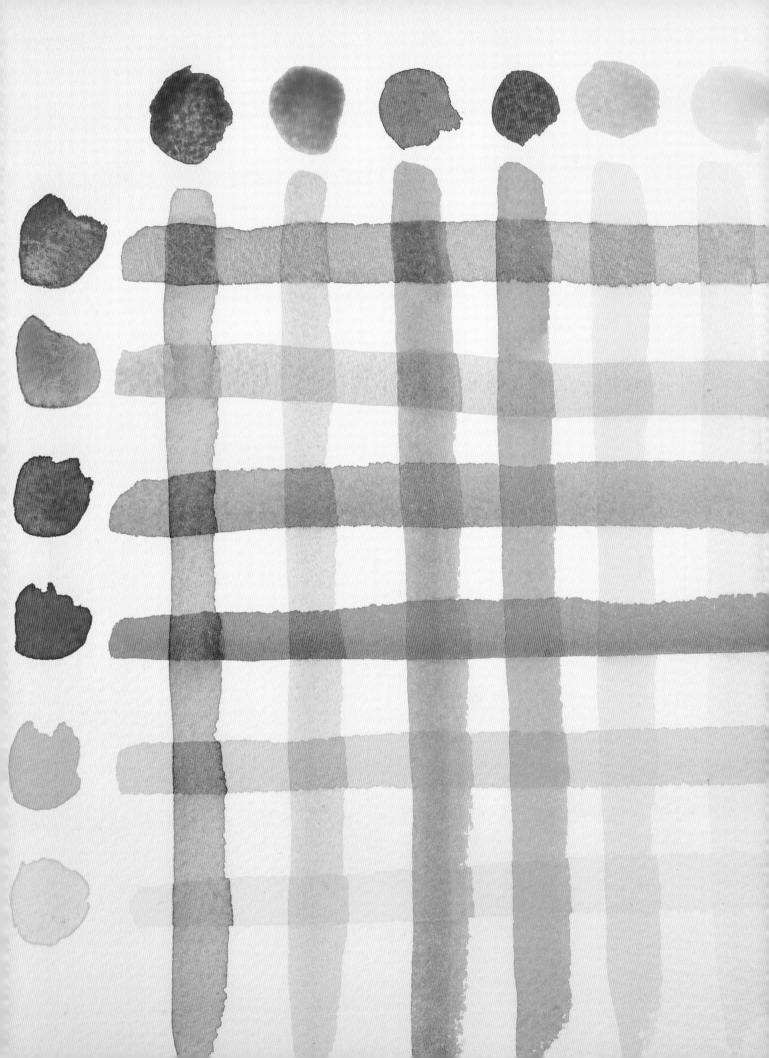

Winter scene

YOU WILL NEED

Paint colours: ultramarine (green shade), sap green, cobalt blue, rose madder

Brushes: large wash brush, size 6 round, rigger

Other: table salt, tracing number 3

A winter scene is a popular choice for the watercolour artist, and the suggestion of snow in the scene does not need to be difficult to portray. You can achieve amazing snow and frost effects by adding ordinary table salt to the colour washes on your paper. Add a little detail – a bare tree, a fence – and you have created a simple, yet wonderful snow scene.

Technique: Working with salt

With salt it is important to pour it from the hand and tap it gently onto the paper. To make smaller voids in your wash using salt, apply the salt to the drier parts of the wash. To make larger voids, sprinkle the salt over the wetter parts of the wash so the salt makes the pigment move more.

Other types of salt, such as sea salt, can be used – larger particles create different effects. It is also worth experimenting to see how damp your wash needs to be to produce the most pleasing effects.

1 Mix ultramarine (green shade) and sap green, and use this to lay a slightly graded wash over the paper with a large wash brush. Sprinkle salt gently over the wash while it is still wet (see technique, above). When the wash is completely dry, dust off the salt to reveal the effect.

2 Mix cobalt blue and sap green; use this mix to lay in the trunk of the tree and its branches using the size 6 brush. Smudge the ends of the branches with your finger to soften them.

3 Take up the rigger to paint in some finer branches in the same cobalt blue and sap green mix. Use the rigger to pull the trunk down into the ground area.

4 Take up the size 6 again and dab in some bushes. Darken the mix and add value to the bushes.

5 Sprinkle more salt into the forms of the bushes you have just painted.

6 Meanwhile, add a touch more cobalt blue to the mix and lay in the foliage on the tree.

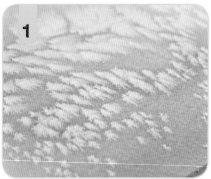

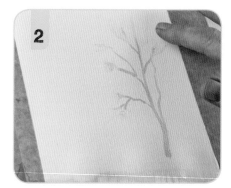

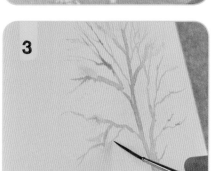

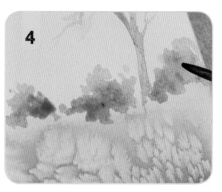

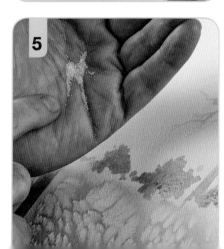

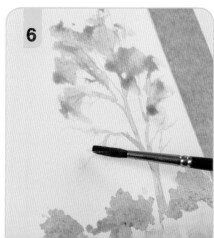

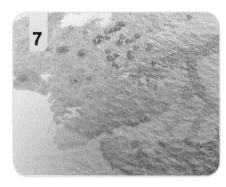

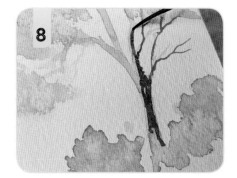

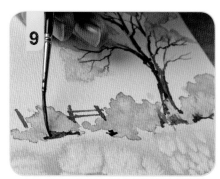

7 Sprinkle more salt into the tree foliage. Let it dry, then remove the salt.

8 Mix ultramarine, rose madder and sap green. With the rigger, fill in the details of the trunk and branches of the tree. Soften the ends of the branches with your finger as before.

9 Draw in a gate and fence details within the hedgerow in the same mix, still using the rigger. Complete the painting with a few shadow details at the base of the tree and the hedges.

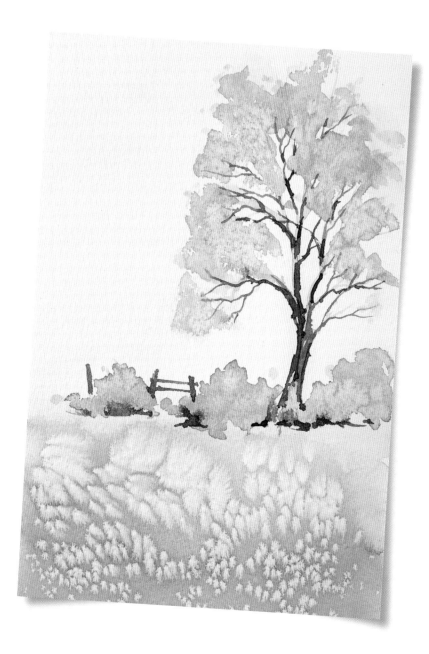

Figures in a glade

YOU WILL NEED

Paint colours: rose madder, ultramarine (green shade), cadmium yellow

Brushes: small filbert, size 6 long round

Other: rag, tracing number 4

Using different values – dark and light tones – of your colours, helps to create variety and depth within a painting; but it can be confusing to concentrate on tone when you are using lots of colours.

Any combination of the three primary colours – that is, red, blue and yellow – can be used for this exercise. The aim of using such a limited palette is to help you to concentrate on mixing different values of the colours and improve your control of the amounts of water used for this purpose.

1 Make up a mauve-brown mix of rose madder, ultramarine (green shade) and cadmium yellow. Apply the colour with the rag, dusting around the edge of the paper and dabbing the colour in. Draw the colour across the bottom of the paper with a rag, to create the ground of a canopy or glade.

2 In a separate well of your palette, mix rose madder, ultramarine (green shade) and sap green to a grey. With the small filbert, dab and twist in the foliage to suggest the shapes of trees leading through the glade. (See page 51 for instructions on the dab and twist technique.)

3 Create some bushes on each side of the glade with the side of the filbert.

4 Lay in horizontal strokes to form a path. Dab in foliage details on both sides of the path.

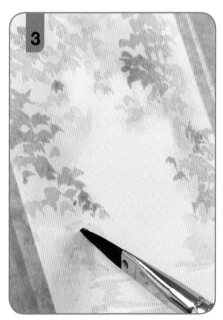

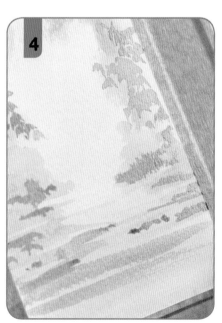

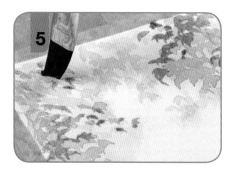

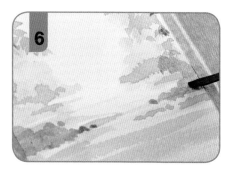

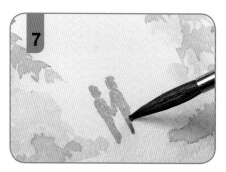

5 Use a mix of ultramarine (green shade) and rose madder to thicken the foliage at the top of the canopy frame, dabbing and twisting with the filbert once again. This adds depth and perspective to the scene. Allow to dry.

6 With the same mix, slightly darkened, dot in some foliage detail along the path, using the size 6 brush.

7 Paint in two stick figures on the horizon, using the size 6 brush, showing them retreating into the distance, hand in hand. You can use this same mix to draw in some additional figures, using a rigger, if you would like. This completes the study.

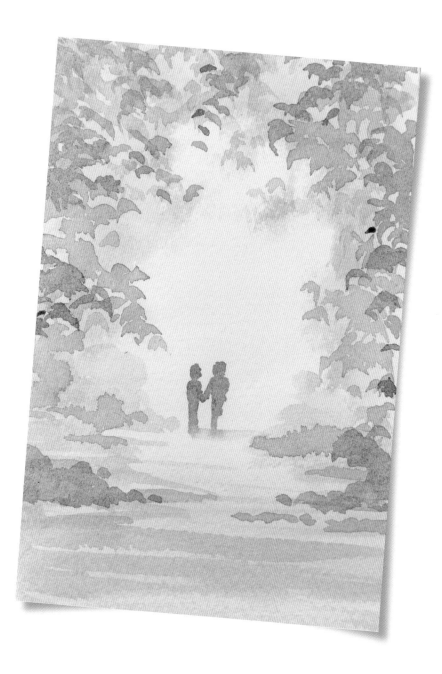

WASHES AND SKIES

Washes are the very essence of watercolour paintings. A wash can cover a large area in a painting or an area as small as a button. One of the most exciting and unique qualities of the watercolour medium is the way in which atmosphere and light can be conveyed by a few brushstrokes swept over white paper. The effects you achieve with your washes depend upon how you apply them.

There are three main washes to consider: the flat wash, the graded wash, and the wet-in-wet wash. Over the next few pages, I explain how to lay each one, beginning with creating a sky using a flat wash.

Winter Mist

35 x 50cm (13¼ x 19¾in)

This painting uses a graded wash as the basis for a wintry landscape.

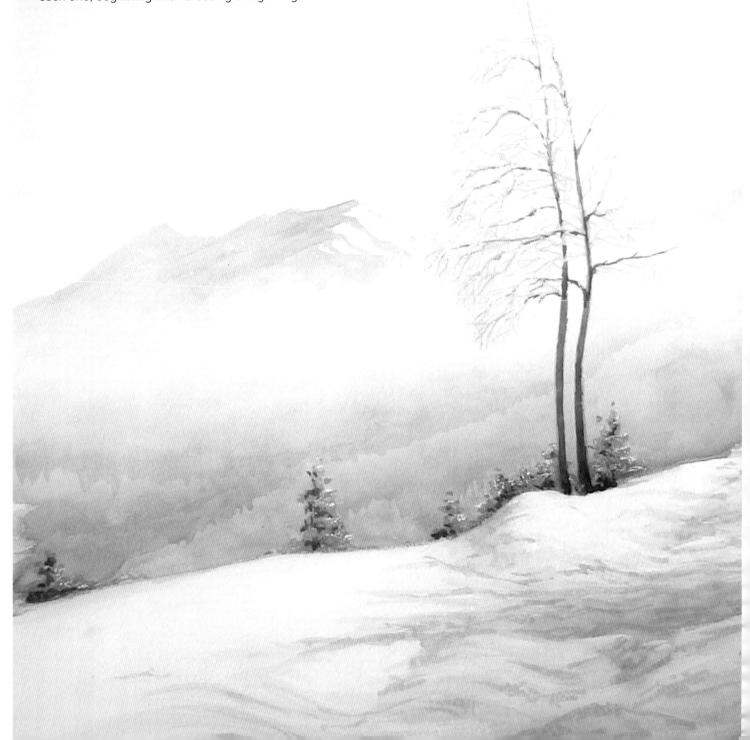

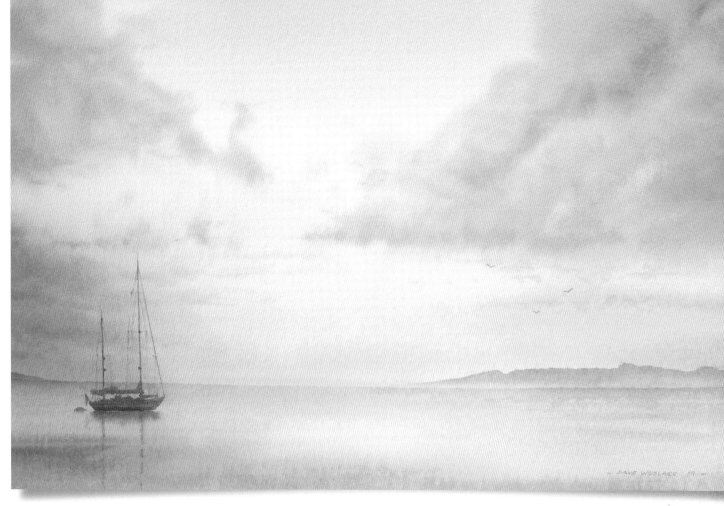

Still Waters,

50 x 35cm (19¾ x 13¼in)

A graded wash was applied first. While the wash was still very wet, the colours for the cloud shapes were applied wet-in-wet using a rag soaked in the paint.

Ten tips for perfect washes

1 Always start with fresh paints, clean water and the equipment you will need close at hand.
2 Make a mental plan of where within your painting you want to apply your colours: for each wash, think it through, visualise it and practise it.
3 Mix large puddles of colour on your palette, creating smooth, even consistencies: mix more than you need.
4 Use a separate brush to apply each colour.
5 Colours applied to wet paper will fade up to forty per cent as they dry, so make your colours strong.
6 Apply the water evenly when wetting the paper to create a uniform shine.
7 Let the water do the work. Flow the paint onto the wet paper with 5–7cm (2–3in) strokes.
8 Add more colour, or different colours, while the paper is still shiny-wet.
9 Tilt your paper to create soft blends and allow the paint to bead.
10 Use a hairdryer on a low setting to dry the surface as evenly as possible.

Practice makes perfect!

Although watercolour painting is challenging, remember: you cannot learn without making mistakes. Just keep practising! The short thirty-minute studies in this book are perfect for helping you develop your skills, so do not hesitate to fill your paper with several, more practised examples of washes. As you practise, you will make fewer mistakes and find that you have more control over the brush and the colour you are applying.

Flat wash

This wash is one in which neither the colour nor the intensity varies. As the term 'flat wash' implies, your aim is to end up with a flat or even wash of colour over the entire area that you're painting. Although you may think of the wash as a simple element within your painting, I should like you to think of it as one of the most important elements, as you can create textures purely with the wash itself.

A flat wash, wet-on-dry, is perfect for large areas such as skies.

Technique: Laying a flat wash

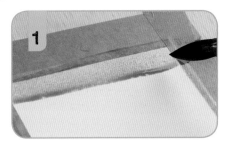

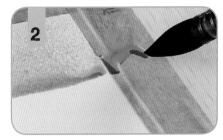

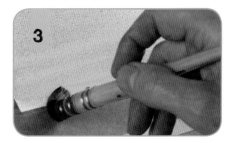

1 With your board at an angle of approximately thirty degrees, apply the wash from left to right using a medium wash brush, from the top of the paper. You should see a bead – or a pool – of wet paint appear at the bottom of your horizontal brushstroke.

2 Reload your brush with paint and continue the wash just below the first stroke, touching the bead of paint as you go.

3 Continue in this fashion (reloading your brush each time) until you fill the whole area of the paper. Try the entire process again with larger shaped brushes and note the differences, then select the brush that works best for you.

PUTTING IT INTO PRACTICE

This painting of a calm, pastoral landscape begins with a flat wash, with the area of land lifted out with a damp rag before the details are applied.

1 Lay a flat wash in ultramarine (green shade) as shown above, keeping your board tilted to allow the colour to bead and run downwards. Lift out the land area with a damp rag, roughly one-third up from the bottom of your paper. With a medium wash brush loaded with darkened ultramarine (green shade), define the edge of the land. Pull out the colour here and there across the top edge of the land.

2 Mix up sap green with a little ultramarine (green shade); drop the colour in along the edge of the line to create a tree line. Allow to dry, then fill in some foreground fields with a weak wash of sap green. Soften the tree line with a stiff brush such as a hog-hair bristle brush.

YOU WILL NEED

Paint colours: ultramarine (green shade), sap green, rose madder, cadmium yellow

Brushes: medium wash brush, sizes 4 and 6 round, hog-hair bristle brush (stiff brush), filbert

Other: rag, tracing number 5

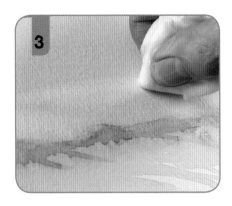

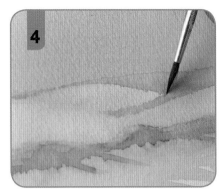

3 With the damp rag, lift out space for hills in the background, and allow to dry.

4 With a mix of ultramarine (green shade), rose madder and cadmium yellow to grey, wash over the far hill, then blend the mix with a damp brush.

5 Add sap green into the mix, and fill in the hill in front. Use a stronger green mix of ultramarine and sap green to fill in the hills in the middle ground. Use sap green glazed in with a dry brush to lay diagonal strokes in the foreground.

6 Use the mix of ultramarine and sap green to reinforce some distant hedgerows; add more sap green to make the mix greener, and add in to the middle hedgerow. Add even more sap green, and brown it off with some rose madder. Use this browned green to scribble thicker hedgerow along the top edge of the middle hill. While this area is still damp add more ultramarine along the bottom edge of the hedgerow coming from the left of the paper.

FINISHING THE SCENE

Use the tracing as a guide for filling in the finer details of this calm landscape.

The dry-stone wall can be dotted in using a mix of cadmium yellow, rose madder and ultramarine (green shade), glazed over with more ultramarine and rose madder once the first wash has dried. The bottom edge of the wall is defined in a mix of cobalt blue, rose madder and sap green. This mix can also be used to lay in the trunk and the branches of the tree. The foliage is applied with a filbert, using a dab and twist technique (see page 51) in sap green, followed by a second layer in ultramarine (green shade).

The foreground is a wash of sap green, with ultramarine (green shade) to define the path edges.

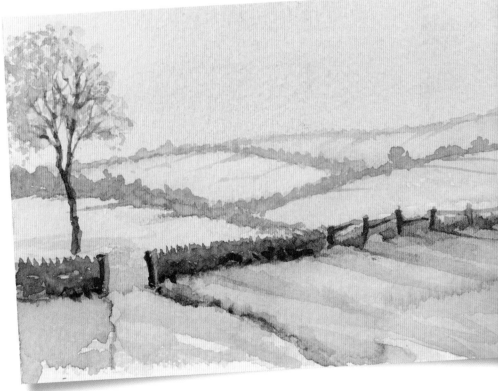

Browning greens

In order to make greens appear brownish, as they may appear on some foliage, add a tiny speck of red or orange to a green mix. At step 6 we have used rose madder to brown the mix.

Graded wash

When looking at landscapes with the naked eye, whether it be the real thing or from a good photograph, we will see many areas of tonal gradation of the same colour. A graded wash, skilfully applied, can represent these areas of gradation well.

When you first apply a graded wash you should use the same techniques as for a flat wash but, as you move down the paper, each new brushstroke should contain a lesser amount of colour and more water.

This wash is possibly the hardest to master, but it offers extensive scope in its application and is ideal for representing many areas in a landscape – not just in the distance but also in the mid- or foreground where there is a definite, and perceptible, gradation of tone and colour.

Work quickly

The action of laying a graded wash needs to be quick to keep the moisture in the pigment; otherwise you will end up with 'cauliflowers' (see page 32).

Technique: Laying a graded wash

1 Load the wash at the top of the paper and wait for it to bead.

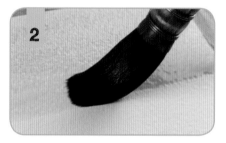

2 Dip your brush into your water pot, then wipe the wet brush across the wash to lighten it.

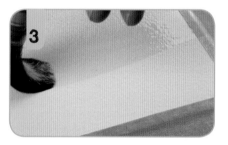

3 Apply the next stroke of colour and allow it to bead again. Dip the brush into the water a third time before you apply the wash.

PUTTING IT INTO PRACTICE

In this scene, the graded wash is used to suggest the low light of a morning sky.

YOU WILL NEED

Paint colours: ultramarine (green shade), rose madder, sap green, cadmium yellow, cerulean blue, cobalt blue, lemon yellow

Brushes: medium wash brush, sizes 4 and 6 round, hog-hair bristle brush (stiff brush), rigger, filbert

Other: rag, paper tissue, tracing number 6

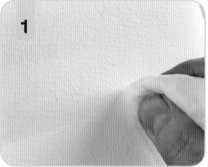

1 Lay a graded wash using ultramarine (green shade) on a medium wash brush, then lift out the land area using a damp rag (see page 30).

2 Mix ultramarine (green shade) with rose madder, and use this colour to drop in some trees and bushes on the horizon line in the bottom third of the paper, using the size 6 round brush. Drag the bottom of the tree line across the paper to soften it, using the tip of the brush.

3 Use sap green to lay in the grass in the foreground with the size 6 brush. Then use a stiff (hog-hair bristle) brush dipped in water to soften the green edge against the tree line.

4 Mix cadmium yellow and cerulean blue. Add rose madder to make a grey-green mix. Work the mix along the horizon line to fill in an extra hedgerow. Use small scribbling motions with a size 4 round brush to suggest the shapes of the individual bushes.

5 Use the same grey-green mix as a base colour for the dry-stone wall running from the bottom-left edge of the paper. Leave a gap in the wall, then continue along the foreground. Then lay in another hedgerow coming from the right edge and establish the outlines of the path leading up to the gate. Wait for the paint to dry, then glaze over it with a mix of cobalt blue, rose madder and lemon yellow, before defining the bricks and the capstones along the top with straight brushstrokes of a rigger. Use the same mix to darken the hedgerows.

6 Put in a tall tree in the foreground with a rigger in a mix of sap green and rose madder. Paint from the ground upwards (the direction of growth) and smudge the ends of the branches with your finger. Go back over the trunk and the branches with the same mix to thicken it before dabbing and twisting in foliage (see page 51) using the filbert, in a mix of sap green with a tiny bit of rose madder and cadmium yellow.

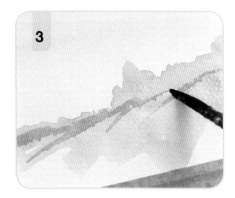

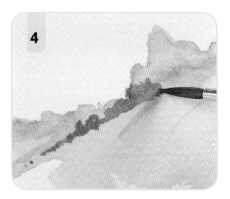

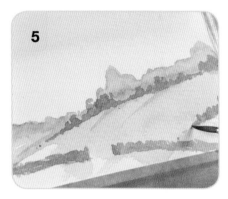

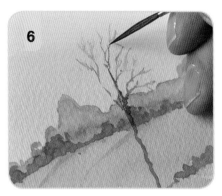

FINISHING THE SCENE

Use tracing number 6 as a guide for filling in the finer details. Lay a flat wash (see pages 24–25) of sap green into the field in the foreground. Run the brush along the top edge of the wall to fill in the field on the right-hand side of the paper, then blend the colour away with a damp brush. Leave an area of light at the top of the wall. Do the same on the left-hand side in the foreground, then draw in diagonal strokes across the field behind the wall to suggest the shape of the hills. Fill in the foreground path in a pale mix of rose madder and cadmium yellow. Finally, draw tiny V-shapes in the sky to represent birds, in a purple mix of ultramarine (green shade) and rose madder. Darken the birds' bodies with a stronger purple mix.

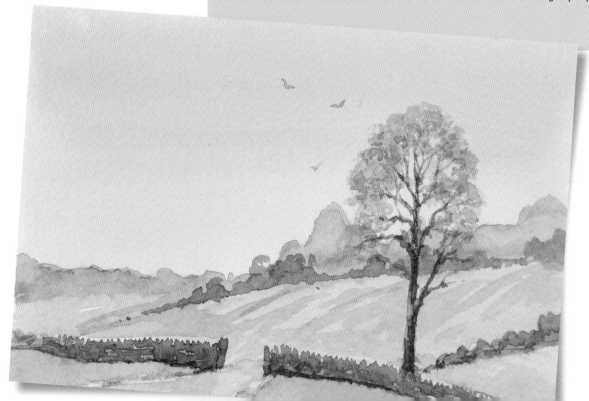

Wet-in-wet wash

A wet-in-wet wash allows you to paint skies that that vary considerably in colour. If done correctly, it can produce a delicate blend from one colour to another as colours meet. This type of wash works well because of the way the watercolour paint moves within the water on the wet paper, mixing and blending on the surface.

This wash is one of the most fluid ways to apply colour as it helps you to achieve a more transparent outcome with some wonderful blends, which is why it is sometimes referred to as a variegated wash. This enjoyable wash offers you the opportunity to fully exploit the medium to produce exciting, interesting and sometimes unusual blends and mixes of colour.

Glazing

A wet-in-wet wash can also be used as a glaze (see pages 16–17).

Technique: Laying a wet-in-wet wash

1 First, lay down a wash of water with a wash brush.

2 Scribble in the base colour – here, ultramarine (green shade) – in the top right corner.

3 Then drop in the secondary colour – here, rose madder – towards the bottom of the paper. Let the washes spread and merge.

PUTTING IT INTO PRACTICE

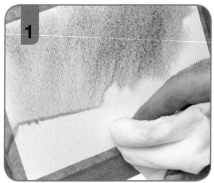

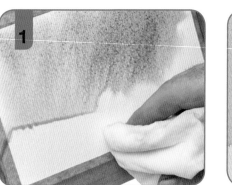

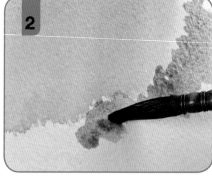

YOU WILL NEED

Paint colours: ultramarine (green shade), rose madder, sap green, cobalt blue

Brushes: medium wash brush, sizes 2 and 4 rigger; sizes 2, 4 and 6 round

Other: rag, tracing number 7

1 This scene begins with a wet-in-wet wash of ultramarine (green shade) and a mix of ultramarine, rose madder and sap green. Blend the two washes on the paper, and tilt your board to allow the colour to move and run down the paper while the pigment is still wet. Use a rag to wipe away the edge of the colour to form the shape of the land.

2 Add more sap green to the mix from step 1 to make a colourful grey. Run the darkened mix along the bottom edge of the wash, using the size 6 brush, to define the land shape. Run the colour all the way across the paper in loose movements to suggest a hedgerow in silhouette.

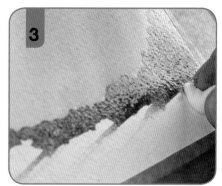

3 Soften the bottom edge of the hedgerow silhouette with the rag, then pull the colour across towards the bottom-left corner of the paper (in the direction of 'eight o'clock').

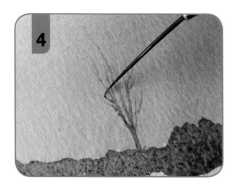

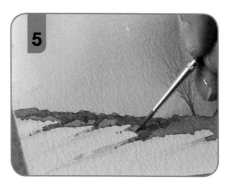

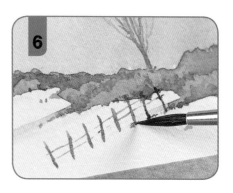

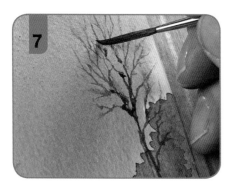

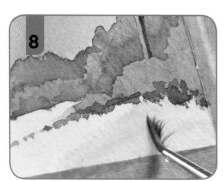

4 Take up a size 2 rigger. Dip it in water, then pull the colour up from the dark mix to create the silhouette of a tree on the horizon.

5 Using a mix of cobalt blue and rose madder on the size 4 round brush, use negative shape painting (see page 15) to create a shape in front of the horizon line, and paint upwards to the horizon to suggest a second hedgerow in front of the first. Strengthen the sweeps of the brush as you move across the page. Represent the detail in the hedgerow with this darker colour, leaving a small horizontal gap along the right-hand edge to suggest light on a tree in the foreground.

6 Lay in vertical marks for fenceposts, and horizontal marks for the fence lines. Darken the bottoms of the posts with a dot in the same mix.

7 Switch to the size 4 rigger. Coming up along the edge of the gap you have left at step 5, draw in the tree on the right-hand edge of the paper. Paint in the direction of growth, and lift away the brush as you reach the tops of the branches, before smudging the ends of the branches with your finger. Paint in some finer branches and smudge these to give the impression of smaller twigs. Under each branch, add some darker detail to create a shadow, then reinforce the shapes of the fenceposts in the same way,

8 Take up pale cobalt blue on the size 4 round and run it down into the foreground. Then use the size 2 round brush to blend the blue away, and run it into the fenceposts to soften them, and complete the scene.

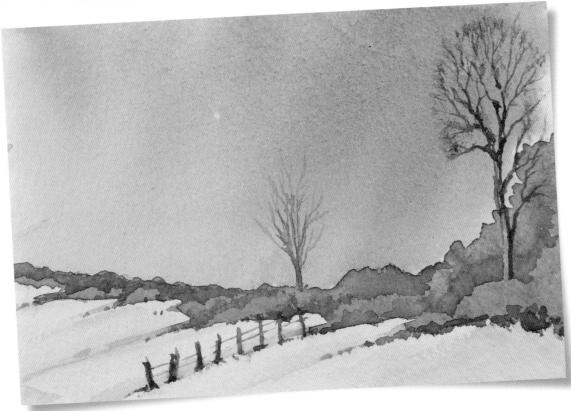

Clouds

Learning how to paint clouds with watercolour is a worry for many aspiring artists, but it needn't be so. All it takes to create successful, realistic clouds is some advance planning with regard to the equipment you need, and a good idea of the kind of sky you're trying to produce.

CREATING CLOUDS

When working clouds into a sky, it is important that your sky colours are neither too pale and weak, nor too dark and strong. Practise on a spare piece of watercolour paper until your sky washes reach your desired consistency and strength.

Timing is also important: whilst your paper is still damp with paint, you have the chance to adjust your sky, such as adding more cloud colours or removing paint (for instance, using a rag) to lighten different areas. Skies and clouds look best with soft edges, so colours that have been allowed to mix on the paper – rather than in the palette – look more pleasing.

On the following pages, I introduce two different methods for creating clouds, using paper tissue, a damp rag and a damp brush.

The clouds, above, have been created using a damp rag.

METHOD 1

1 Lay a graded wash in ultramarine (green shade) using a medium wash brush. Using a scrunched sheet of paper tissue, lift out the damp colour to create the clouds (see technique, below). Then lift out the moisture from any sharp edges of the clouds.

2 Wet a stiff brush, such as a hog-hair bristle brush, then go in and soften the edges of the clouds.

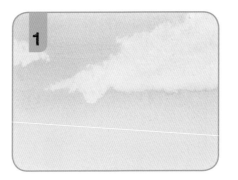

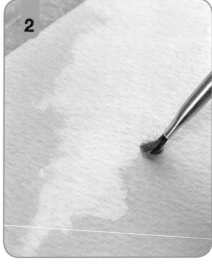

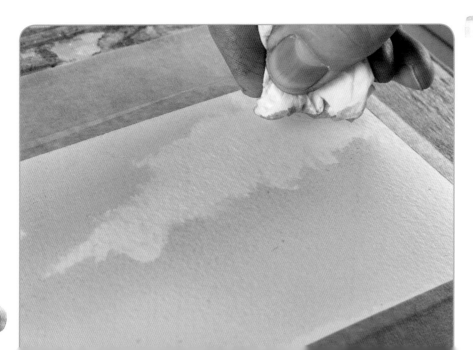

Technique: Lifting out

Lifting out is an excellent way to create a texture or to modify the value of any wash which is still wet. You can use paper tissue, kitchen paper or a rag to achieve some fantastic effects. These items can be used dry or damp – try them for yourself, and take note of the different results.

METHOD 2

Painting shadows on clouds can be tricky because it is undesirable to create edges on the shadow colour. Using a damp brush will ensure that the colour blends softly into the lighter cloud areas.

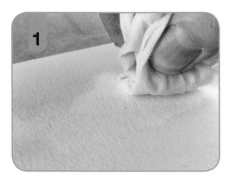

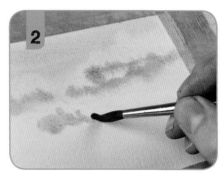

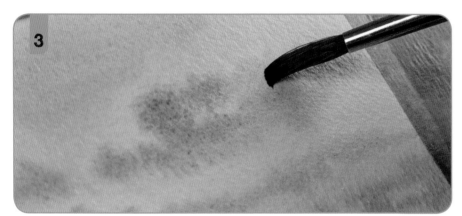

Drying time

It is important to let the clouds dry before laying on a new wash or glazing, as we are doing here; allowing the clouds to dry results in softer edges.

1 Lay a graded wash in ultramarine (green shade) using the medium wash brush. Lift out the shapes of the clouds with a damp rag.

2 Once this has completely dried, paint a clean wash of water over all of the clouds. To add the dark shadows, make up a mix of rose madder and ultramarine (green shade). Use sap green to grey the mix. Take up the medium wash brush again and before the clear water wash has dried, paint the shadow shapes in the lower area of the clouds.

3 Darken the mix and use a size 6 round brush to darken the shadows and drop in some smaller clouds. Manipulate the tops with a damp brush. This way, you ensure you only end up with soft shadows.

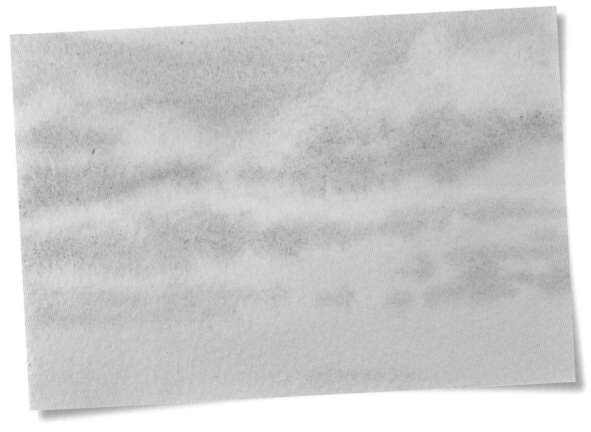

Stormy night

This study introduces a slightly different method of working in clouds: by painting them in silhouette form only, This exercise begins with a graded wash sky.

YOU WILL NEED

Paint colours: ultramarine (green shade), rose madder, sap green

Brushes: medium wash brush, size 6 round

Other: rag, tracing number 8

1 Start by laying a wash of ultramarine (green shade) at the top of the paper, using the medium wash brush. Mix ultramarine with rose madder, and lay in this second wash underneath the ultramarine, wet-in-wet, to the bottom of the paper.

2 Run the wash brush, loaded with water, across the page.

3 Run in a thin wash of a darker mix of ultramarine, rose madder and sap green in the middle section of the paper.

Avoiding cauliflowers

if you are too slow to add the wet paint over the original wash at step 1, you will end up with 'cauliflowers', patches of colour with frilled edges, like cauliflowers. Always apply wet colour into wet, glistening colour on the paper. Avoid applying wet colour into slightly dried colour, which causes the cauliflower effect seen below:

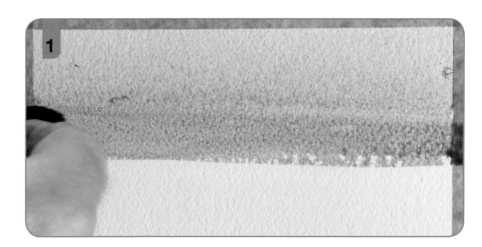

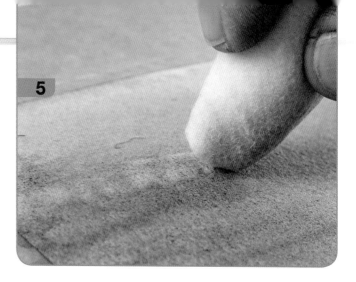

4 As the dark mix starts to dry, dot more colour in along the middle of the paper. Make sure the dark mix is not too wet: if the next layer of paint spreads too much, you will lose the definition of the cloud shapes. Lay another stroke of the darker colour beneath the first, coming in about one-third across the paper. Do the same from the right-hand edge of the paper. Keep filling in the edges of the clouds with the darker mix, wet-in-wet, with the medium wash brush.

5 Soften and lighten some areas of the clouds with the damp rag, lifting out the colour. In particular, use this method to lighten the centre of the paper to suggest a misty moonlight. Allow to dry.

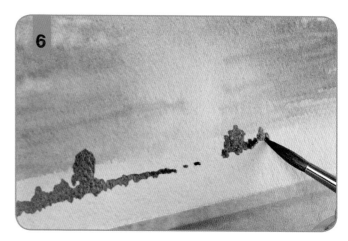

6 With the dark mix of ultramarine, sap green and rose madder, dot shapes across the near-bottom of the paper with the size 6 brush, to create a hedgerow with one or two vertical fenceposts for interest. This completes the painting.

Pale dawn sky

One of the qualities of the watercolour medium is its capacity to produce light, delicate effects in a painting. This study uses a blend of light colour washes to create the impression of a glowing dawn sky.

YOU WILL NEED

Paint colours: ultramarine (green shade), rose madder, yellow ochre, lemon yellow, cobalt blue

Brushes: sizes 4 and 6 round, small wash brush, rigger

Other: rag, tracing number 9

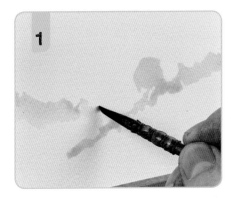

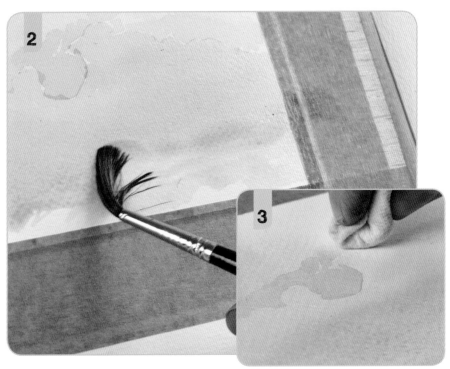

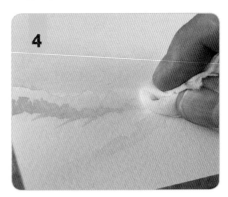

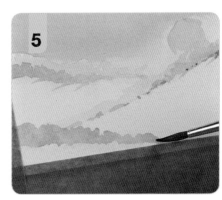

1 Using the size 6 brush, suggest hillsides in a weak mix of ultramarine (green shade) and rose madder, coming from either side of the paper. Soften the bottom edges of the hillsides with the rag.

2 Create a wet-in-wet sky. Begin with a mix of yellow ochre with lemon yellow. Turn the paper upside-down, and paint the watery yellow mix negatively below the tree line. While the yellow mix is still wet, drop in a wash of rose madder mixed with cobalt blue beneath it, using the wash brush. Keep this wash fairly loose. Add a very weak cobalt blue wash along the top of the sky (at the bottom of your paper). The rose madder forms a barrier between the blue and the yellow mix so you will avoid ending up with a green sky.

3 Soften off the edge of the sky nearest the tree line, with the rag.

4 Mix cobalt blue, rose madder and lemon yellow into a colourful grey (beginning with the blue and red and then adding the yellow to grey the mix). Dot in a distant hedgerow coming from the left of the paper using the size 4 round; dab the hedgerow with the rag to lighten the right-hand 'edge' of the hedgerow. Use the same mix to dot in darker details along the hillsides depicted in step 1.

5 Add more blue and more yellow to the mix from step 4 and bring in the lower hedgerow, coming from the left edge of the paper, in small circular motions. Dab with a damp rag to soften the bottom edge. Use the same mix to fill in darker details in the middle of the central hedgerow.

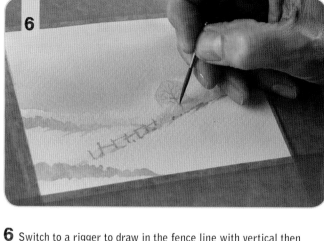

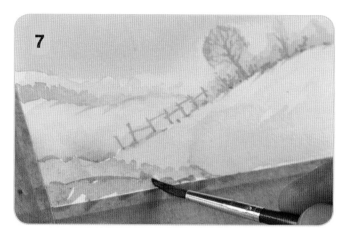

6 Switch to a rigger to draw in the fence line with vertical then horizontal marks in the same blue-grey mix. Use the rigger to bring in the details of the tree on the horizon. Dot in more, darker shadows on the tree at the base, and on its branches, then dot around the edge of the tree crown. Suggest a second, smaller tree on the horizon to the right of the original.

7 Switch back to the size 4. Mix up a summery green with cobalt blue and lemon yellow, and fill in the foreground field with a flat wash. Blend the mix with water, and dot it into the top of the hedgerow in the foreground. Add rose madder to grey the green, and lay a flat wash in the field in the bottom-left corner of the scene. Mix a brown-green with rose madder, lemon yellow and a little cobalt blue and stipple in the details of the foreground field, and the base of the foreground hedgerow. Finally, add rose madder to cobalt blue to make a strong purple, and lay in a third tree in the bottom-left corner of the scene with the rigger. Smudge the ends of the branches to soften them, and then enhance the branches with a darker purple mix.

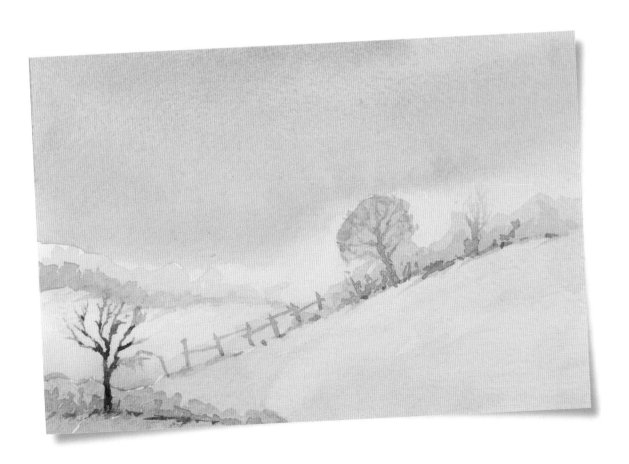

A moody sky

Another quality of watercolour painting is the ability to create a dark moody atmosphere in a painting. Using the wet-in-wet technique, stronger mixes of colour can be blended together and different effects can be achieved using various mixes of colour and strength.

YOU WILL NEED

Paint colours: sap green, ultramarine (green shade), rose madder

Brushes: size 6 round, rigger, small wash brush

Other: rag, tracing number 10

1 Draw in the land first in a grey mix of sap green and ultramarine (green shade).

2 Soften the bottom edge with the rag.

3 Darken the mix and lay in a middle-distance tree line below the first tree line. Leave a gap in the tree line to add in a gate later. Soften the bottom edge of the tree line with the rag, then allow to dry.

4 Using a rigger and the same dark green mix as for step 3, paint in an open gate and two gate posts in the gap in the tree line. Allow to dry.

5 Turn the board upside-down so you are working from the bottom of the scene to the top. Lay in a first wash with rose madder using the size 6 round brush or a small wash brush.

6 Next, lay in a wash of ultramarine (green shade) on its own below the rose madder wash, wet-in-wet.

Keep the bottom wet

When laying this graded wash, keep the bottom edge of each colour wet and ready for the next wash.

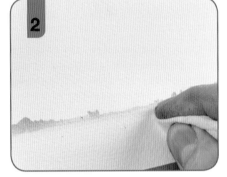

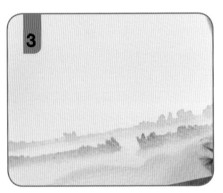

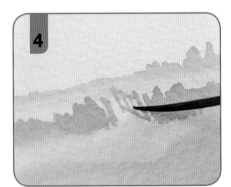

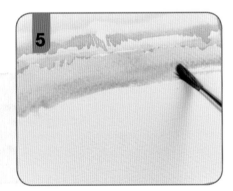

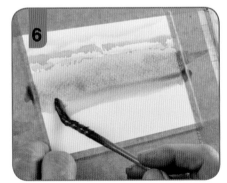

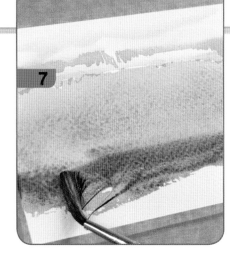

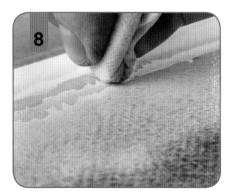

7 Mix ultramarine (green shade) with rose madder, and lay in as the last wash.

8 Soften the edge of the first (rose madder) wash against the tree line with the damp rag.

9 Turn your board back 180 degrees. Make up a grey-green mix of sap green, ultramarine (green shade) and rose madder, and dot this colour along the edge of the foremost tree line.

10 Finally, use water and a damp brush to soften the paint into the tree line and the details of the gate to complete the painting.

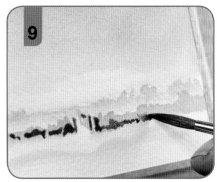

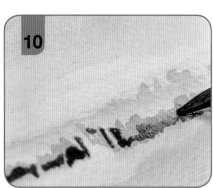

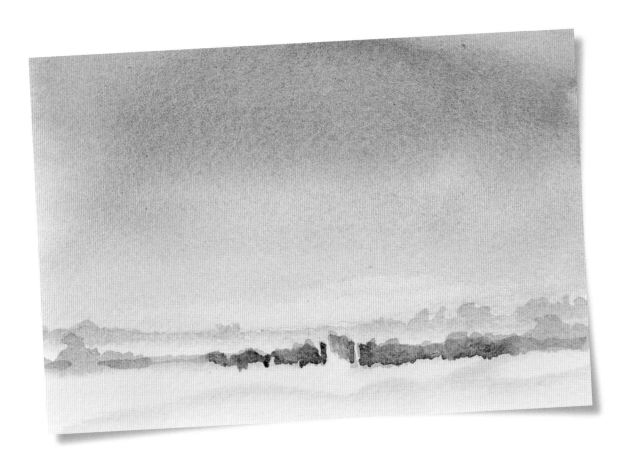

COMPOSITION

Composition, despite all that has been written about it, is not an exact science. There are no definite rules regarding what should or should not be done, only many guidelines. The composition of your picture should merely provide a structure to your watercolour landscape. A well-thought-out composition will control, or at least suggest, where the eye of the viewer should look, encouraging them to absorb everything that the painting has to offer before settling on the focal point. Your personal preferences and instincts also play an important part in the composition of the painting; it is your painting, after all!

THE KEY ELEMENTS

When you are planning the overall appearance of a landscape painting, it is important to familiarise yourself with the following elements:

Picture format The size and shape of your painting surface.

Focal point The main centre of interest (or focus) in your painting.

Overlapping Elements within the painting that overlap to help give the impression of distance and depth.

Lead-ins Elements and brush marks used to guide the viewer through the painting, either initially or ultimately to the focal point.

Balance A stable arrangement of elements within a composition.

Contrast Strong light and dark values that create shapes and patterns in your composition.

Aerial perspective An effect that helps portray atmosphere and depth, often seen in a landscape

Campsall Wood

40 x 60cm (15¾ x 23½in)

Initially a graded wash was applied, followed by paler washes which were used to recede the background. Stronger colours and contrasts were used in the focal area to create interest.

AERIAL PERSPECTIVE

An understanding of aerial perspective is essential for any landscape artist. When the human eye looks into the far distance of a landscape, distant objects appear to look less colourful, and rather grey; the contrast of lights and darks reduces, and details diminish. This is because of the atmosphere through which distant objects are seen. The further away from the object you are, the more atmosphere you are looking through: this atmosphere contains tiny water droplets and other small particles such as smoke and dust. All these minute particles act as a filter, which will only allow certain wavelengths of light and colour to pass through. Blues and greys pass through this filter more easily than warmer colours – like reds and yellows – which have longer wavelengths.

The painting below perfectly demonstrates the application of aerial perspective: in the far distance you can see only the most basic of tree shapes. The tree in the midground is of a slightly stronger value, with a little more detail than the distant line of trees. The tree in the foreground has the strongest value and shows the most detail.

Climate and weather

The actual content of the atmosphere varies from one day to another, from country to country. The weather also plays a big part in how much you can see of objects in the distance.

Below, a scene that demonstrates aerial perspective.

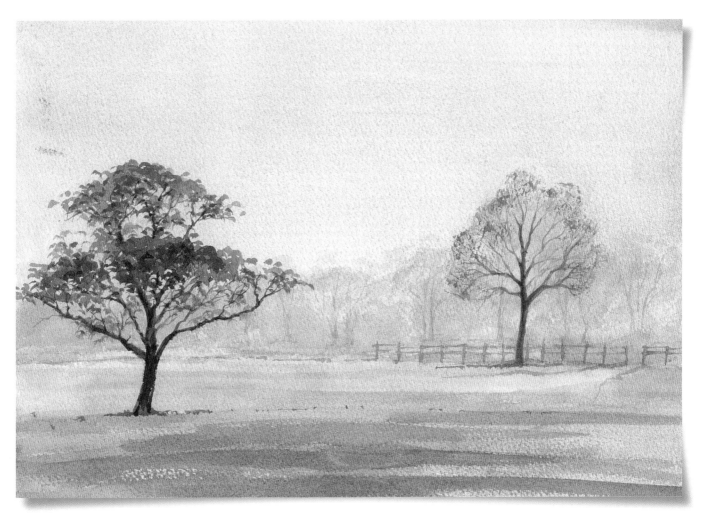

By the lake

One way in which you can produce a complete landscape in a short space of time is to simplify what you see.

This study is produced primarily with a damp rag, and depicts only a small amount of detail that has been painted with a brush; yet the consideration of aerial perspective adds depth and interest to this simple scene.

1 Stick a strip of low-tack tape along the bottom of the paper. Using the rag, dab the shape of a distant hedgerow in a very weak grey mix of cobalt blue and burnt sienna along the top edge of the tape. Dampen the rag and soften the right-hand side of the painted-in area, then leave to dry.

2 Peel off the tape, and move it down the paper slightly lower than the bottom edge of the hedgerow you have just painted in.

3 Make up a stronger mix of burnt sienna and cobalt blue: dab a second line of hedgerow over the first. Dampen the rag and soften the right-hand side of the hedgerow area again. Allow to dry.

4 Remove the tape and reposition it slightly lower on the paper and towards the right hand edge. Add sap green to the grey mix and use the rag to dab the mix across the page. Suggest a tree on a hilltop on the right of the scene.

5 Add yellow ochre to the mix. Switch to the size 6 brush and brush in the colour at the foot of the lowest hedgerow, and into the crown of the tree. Dampen the brush and soften the blend. Remove the tape.

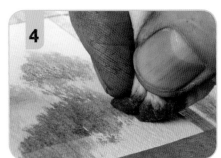
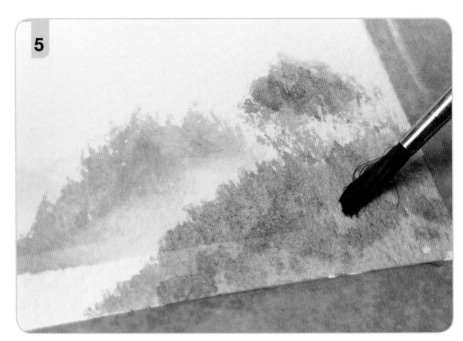

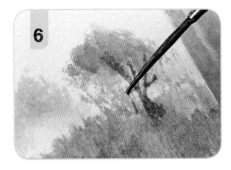

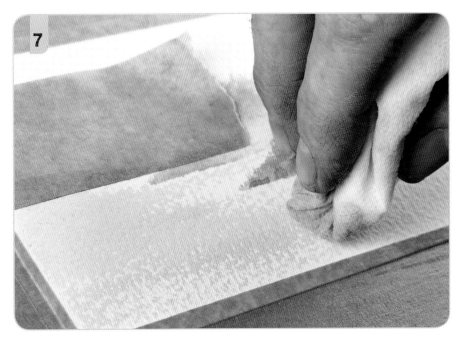

6 With the rigger, add in burnt sienna and cobalt blue for twigs and trunks. Use the same mix to suggest the details in the hedgerows and the crown of the tree.

7 Reposition the tape at the top-left of the paper, leaving a small gap at the top. Load cobalt blue onto the rag, and dry-brush the blue across the page left to right, to represent water and complete the picture. (See page 53 for information on applying the dry-brush technique.)

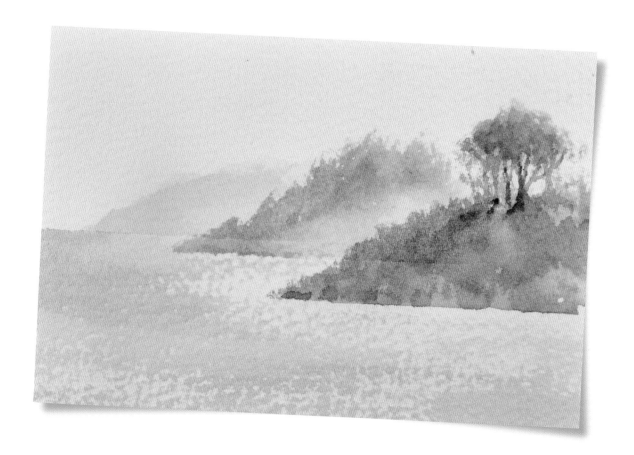

Fences

Fences are a great way to add interest to a painting and for creating a lead-in that controls the viewer's way of looking at your painting.

The juxtaposition of two fence lines at differing angles adds dimensionality to this composition.

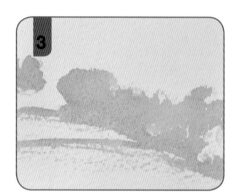

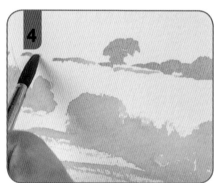

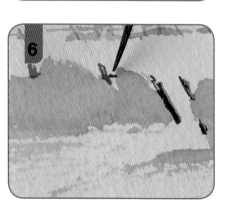

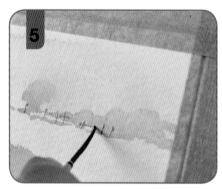

1 Begin by laying a graded wash in sap green using the large wash brush. Darken the sap green, then create a hedgerow a third of the way down the paper, wet-in-wet, using the size 6 round brush.

2 Apply a dry-brush technique (see page 53) at the end of the hedge to give it more texture.

3 Sweep in more green mix for the foreground in front of the hedgerow, again using a dry-brush technique.

4 Make up a mix of ultramarine (green shade) with a small amount of sap green to paint in distant trees on the horizon. Soften the trees on the horizon by dabbing with a damp rag. Allow to dry.

5 Take up the rigger loaded with ultramarine (green shade). Along the horizon, drop in vertical marks to represent the fenceposts, and link them with horizontal marks for fence slats.

6 Next, load the rigger with burnt sienna. Drop in two vertical marks on either side of the gap in the hedge, to create fenceposts. Drop in several more vertical strokes along the length of the hedge. Join up the posts with horizontal strokes for fence slats. Allow to dry.

7 Take up a small wash brush and paint clean water over the hedge to lay a basis for wet-in-wet work. Make sure the water glistens before you begin to work wet-in-wet at step 8.

8 Add a mix of ultramarine (green shade) and sap green into the bottom edge of the hedge using the size 6 brush. Drop the same mix into the foreground for texture, then dab the hedge with the rag to soften the wet area.

9 With a mix of ultramarine (green shade) and burnt sienna on the rigger, add dark shadows to the fence. Allow to dry, then use the same brown mix to indicate the ruts at the bases of the fenceposts.

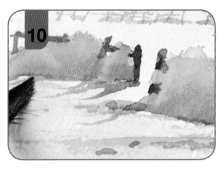

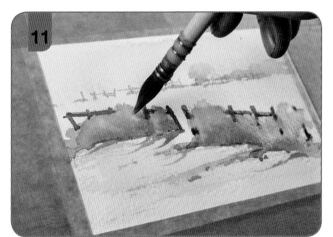

10 With a wash of lemon yellow on a small wash brush, fill in the grasses in the foreground.

11 Paint more water over the hedge, then, still with lemon yellow on the small wash brush, reintroduce light into the hedgerow, to complete the painting.

Fence line in the snow

This simple study makes use of a piece of cardboard dipped in paint and used as a stamp, to depict receding fence lines.

1 Lay a cobalt blue wash using the large wash brush. Mix ultramarine (green shade) with a little rose madder; dip the short edge of a rectangular card stamp in the paint, and use it to stamp in a row of fenceposts decreasing in height towards the horizon line.

2 Soften the posts with the damp rag.

3 Create some distant bushes and trees with the corner of the stamp and soften again with the rag.

4 Drag the corner of the stamp diagonally down the paper to suggest tracks in the path running alongside the fence. Then stamp in the fenceposts on the right-hand edge of the path.

5 Make up a mix of ultramarine (green shade) and burnt sienna and, using the rigger, draw in the trunk and the twigs of the trees and bushes in the distance.

6 Use the rigger to refine the fenceposts.

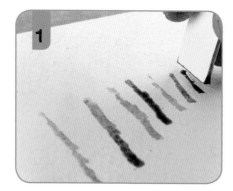

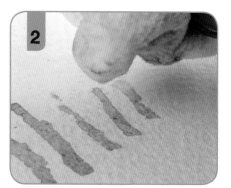

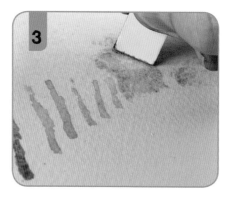

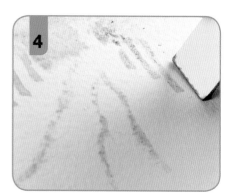

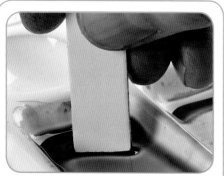

Technique: **Stamping**

Dipping a cardboard stamp into paint allows for a certain degree of uniformity in your mark making, as well as variety of form and texture. There are plenty of items you could use as stamps, and you should experiment to see the marks and textures you can create by loading the stamps with colours of varying intensities.

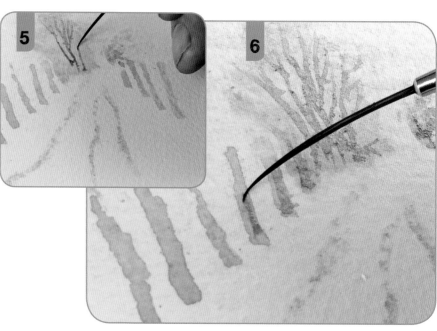

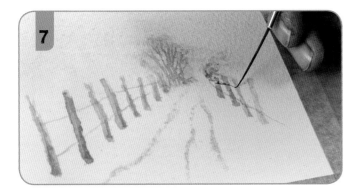

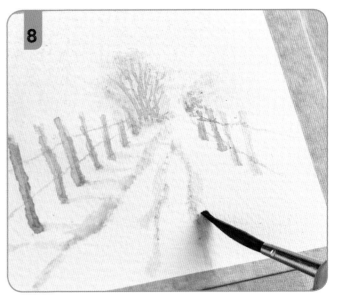

7 Still with the rigger, fill in the wires between the fenceposts on both sides of the path. Make the paint more faint as you move towards the horizon line to make the wires look as though they are receding into the distance.

8 Finally, load the size 6 brush with a weak wash of cobalt blue, and lay in the shadows of the fenceposts and the snowy path.

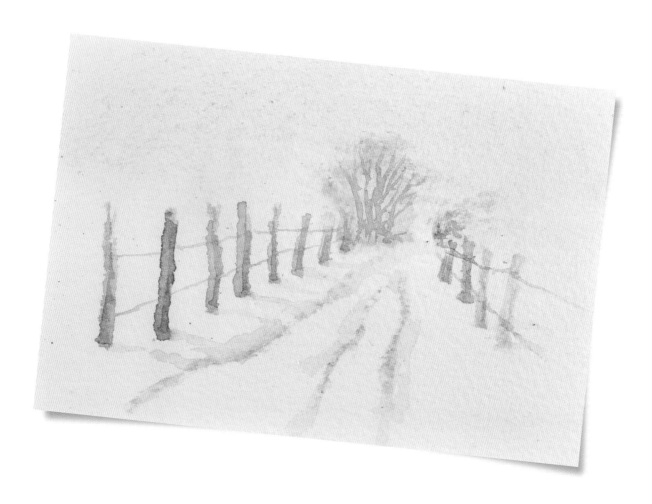

TREES AND FLOWERS

I t is nearly impossible to create a landscape and not incorporate trees or foliage. When you consider how many different varieties of plants, flowers and trees there are, it can be daunting to think of painting all those leaves and branches. However, by simplifying the tree shape, and breaking it down into light areas, shadow, colour and basic texture, it is possible to capture the impression of the detail, without painting the exact shape of every branch, twig and leaf.

It will help you to have a basic understanding of trees in order to give a realistic impression of them. All trees have a distinctive structure: they all have roots, a trunk, branches, twigs and foliage, which grows into certain standard shapes. There is, of course, a certain amount of variation depending on the age, the species and growing conditions of the tree. Try to look at a tree as a whole, with component parts: perceive a tree as a simple block shape, similar to a silhouette, then look for the largest masses into which the main form is subdivided.

One method of painting trees and foliage is to look at your subject closely before you even pick up a brush. Squint, if it helps, and think of the tree in blocks as mentioned above. Each block of shapes will require a different technique and colour value. Try to make quick pencil sketches of the overall outline shape and the main light and dark masses.

Poppies,
30 x 50cm (11¾ x 19¾in)

Initially, I applied a graded wash and lifted out the cloud shapes using a damp rag. I used a yellow wax crayon to draw the poppy stalks, and masking fluid to mask out the shapes of the poppy heads.

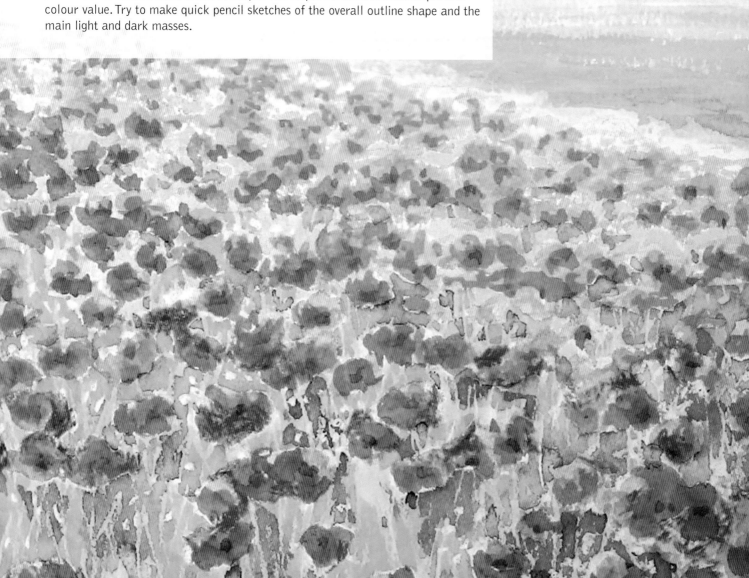

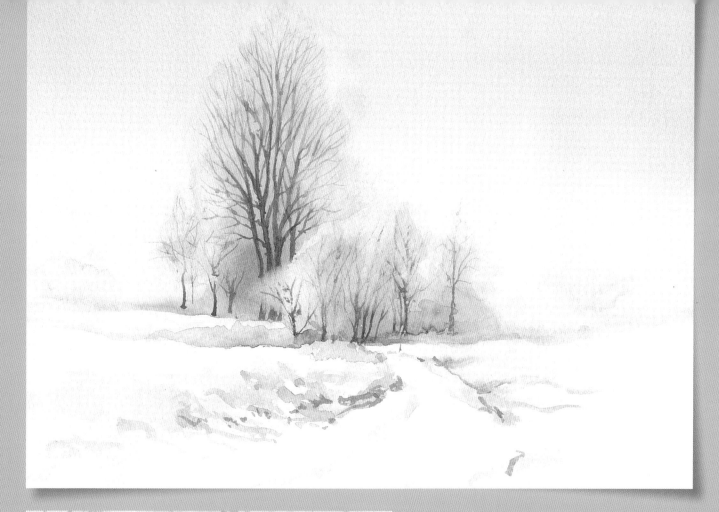

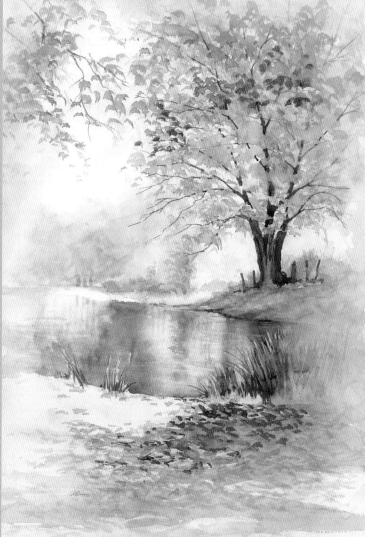

Winter Copse, 34 x 25cm (13½ x 9¾in)

This scene began with a graded wash, and the basic shapes of the trees and hedgerow were suggested using a damp rag loaded with colour. I added detail using a fine brush.

Colourful Leaves, 30 x 50cm (11¾ x 19¾in)

I applied the basic pale washes with a damp rag loaded with each colour in the background and foreground. The colours in the water and the negative shapes of the foreground grasses were produced using the wet-in-wet technique (see pages 28–29). The dab and twist technique (page 51) was used to create the foliage.

Hedgerows

Hedgerows are a constant source of inspiration, with their abundance of plant life and colour, woven together into interesting shapes, colours and patterns. Hedgerows are also useful for creating a lead-in into your painting.

This misty morning scene uses aerial perspective to suggest atmosphere and a sense of distance.

1 Begin by laying a wash of cobalt blue at the top of the page with the large wash brush. Working wet-in wet, continue the graded wash by laying a wash of sap green below the cobalt blue. Allow to dry. Paint in the first, most distant hedgerow using a mix of cobalt blue and burnt sienna on a size 6 round brush, using a loose scribbling motion. Soften the bottom edge of the hedgerow with a damp rag, then allow to dry.

2 Next, fill in the hedges and trees in the middle ground in the same cobalt blue and burnt sienna mix. Work at a slight angle to the horizon you have already filled in. Use the damp rag to soften the bottom edges once again.

3 Add sap green to the mix of cobalt blue and burnt sienna and fill in the shapes of trees and bushes in the foreground. Leave a gap near the centre of the hedgerow for a stile to be painted in. Soften the bottom edges of the hedgerows with the damp rag once again.

4 Take up the rigger, and load it with sap green mixed with burnt sienna to paint part of a fence and a stile into the hedgerow.

5 Working quickly, wet-in-wet, load the rigger with sap green, darkened, and work along the base of the hedgerow to 'fur' it up. Here, we are using cauliflowers on purpose to add texture to the painting. Allow to dry.

6 Using a strong mix of burnt sienna and ultramarine (green shade), dab in detail – still using the rigger – along the bottom of the hedgerow and onto the fenceposts and the stile.

7 Dot in masking fluid (see technique, right) along the bottom of the hedge line with the colour shaper; this is where a patch of wildflowers will be painted in at step 11.

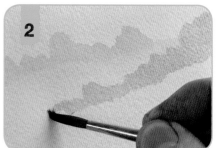

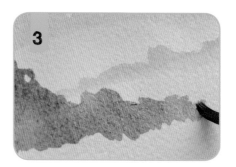

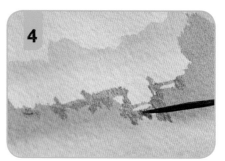

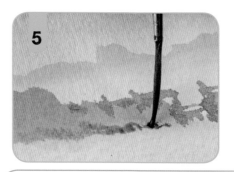

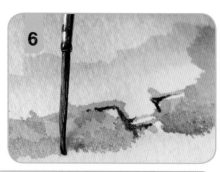

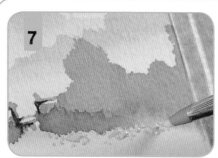

Technique: Using masking fluid

In addition to the tools listed on page 9, you can apply masking fluid with a rubber-tipped colour shaper for precision.

Avoid applying the fluid to a wet or damp surface, and allow the fluid to dry fully before you attempt to remove it.

8 Lay a wash of sap green over the masking fluid areas with the size 4 round brush, all the way across the paper. Pull out some of the green to suggest the edges of a path in the foreground. Move up into the bushes along the left-hand edge of the paper. Use negative shading to suggest more bush detail. Darken the green with ultramarine (green shade) wet-in-wet, and fill in more foliage shapes. Repeat for the hedgerow directly above the masked flower area to help the foreground stand out more.

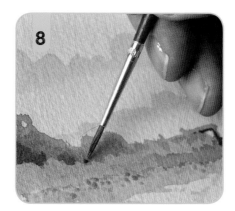

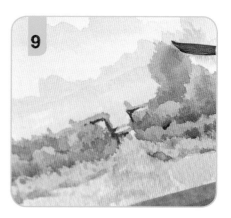

9 Mix cadmium yellow and rose madder to throw in the path using a dry brush technique with a small amount of water. Add cadmium yellow and sap green to make a yellow-green and fill in the foreground grasses. Add the same mix into the rear field; fade the mix into the misty hedgerows in the background, then use ultramarine (green shade) to soften the foremost misty hedgerow.

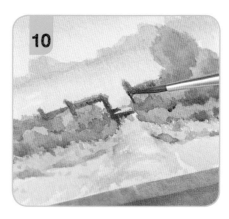

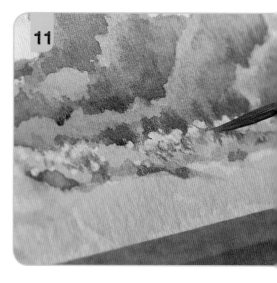

10 With a mix of cadmium yellow, rose madder and sap green, add shadow and dark detail to the fenceposts and stile. Allow to dry.

11 Rub off the masking fluid with your finger.
Finally, dot in some flowers in rose madder over the areas left by the masking fluid, using the tip of the size 4 round. Do the same with cadmium yellow to complete the scene.

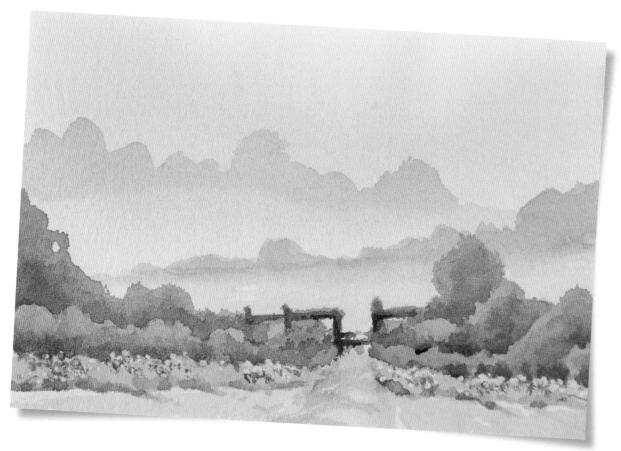

Layered foliage

YOU WILL NEED

Paint colours: cadmium yellow, sap green, burnt sienna, ultramarine (green shade), rose madder

Brushes: small filbert, rigger, small wash brush

Suggesting foliage in a painting can be daunting, depending on the level of detail you want to achieve. When painting a tree's foliage from a distance, artists will usually look for areas of colour and paint the shapes of those blocks of colour, but depicting individual leaves may prove more difficult. Here, I demonstrate my own method for successfully depicting a mass of foliage in layers of natural colour.

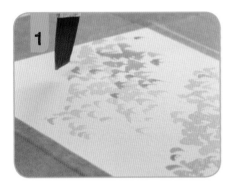
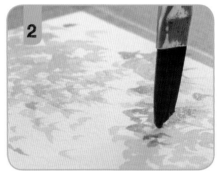
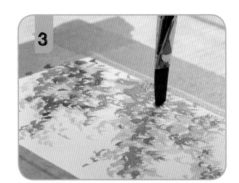

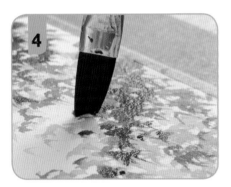
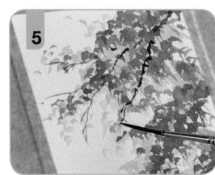

1 Start with cadmium yellow mixed with a hint of sap green. Working from the top right-hand corner down towards the bottom-left corner, use the small filbert to dab and twist over the surface of your paper to suggest the texture of leaves (see technique, opposite).

2 Introduce sap green on its own and dab and twist another layer over the top of the first layer of leaves.

3 Add a third layer using burnt sienna.

4 Make up a strong mix of burnt sienna and sap green, and dab and twist in a new layer of colour. Then allow to dry.

5 Make up a mix of ultramarine (green shade) and rose madder. Using the rigger, bring in some branches and twigs. Draw them down in the direction of the foliage – that is, from the top-right corner of the paper to the bottom-left corner. Allow to dry.

6 Switch to the small wash brush, and lay in a wash of ultramarine (green shade) around the foliage to suggest depth.

7 Finally, take up a strong mix of burnt sienna and ultramarine (green shade) on the rigger again, and intensify the twigs in the more shadowy areas.

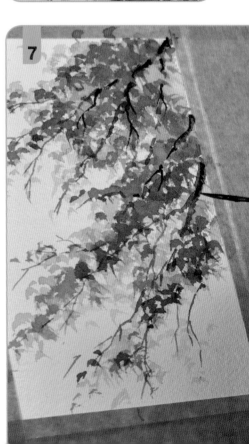

TREES AND FLOWERS

Technique: **Dab and twist**

I have developed a technique to depict both individual leaves and masses of leaves, which I call the 'dab and twist' technique. The dab and twist technique is best achieved using a filbert brush, which has a head of bristles that form an oval shape. It is essential to practise the dab and twist technique before you apply it to a painting.

Load the filbert with your chosen colour and dab your brush up and down (1) on the surface of your paper. As you dab up and down, start to twist the brush between your thumb and forefinger (2). You will see different shapes appear, which closely resemble leaves. Move your brush around the paper using lesser and greater pressure for varied effects. To create smaller leaves use a light touch; for larger leaf shapes use more pressure on the downward stroke.

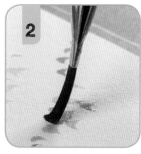

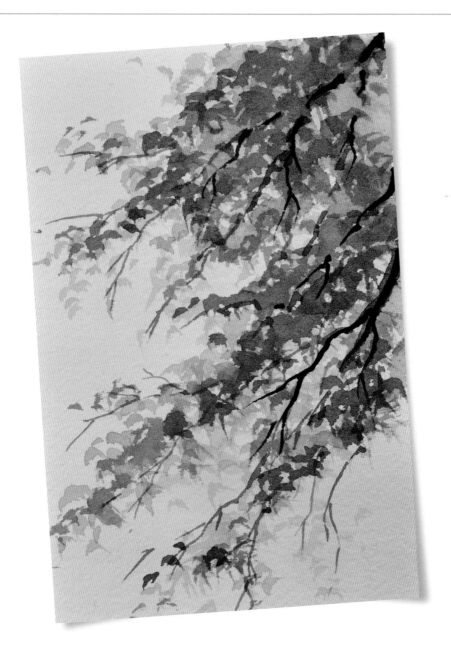

YOU WILL NEED

Paint colours: lemon yellow, sap green, ultramarine (green shade), rose madder

Brushes: rigger, medium wash brush

Other: natural sponge, tracing number 15

Spring foliage

This project makes great use of the natural sponge as a stamp with which to create the foliage texture. With this technique not only can you create some of the smaller leaf shapes but also masses of leaves that look like bushes or trees.

1 Begin by dabbing in areas of lemon yellow using the sponge as a stamp.

2 While the yellow is still damp, make up a mix of sap green and ultramarine (green shade), and dab this in on top of the yellow, wet-in-wet. Allow to dry.

3 Mix rose madder, ultramarine (green shade) and sap green; with the rigger, use this mix to draw in the trunk and the branches of the largest tree. Then draw in some additional bare branches along the hedgerow.

4 Dip the sponge in a well of ultramarine (green shade) on its own: dab in this darker colour on the large tree, and along the hedgerow, over the bare branches.

5 Make up a new mix of sap green and lemon yellow. Using the sponge as a dry brush (see opposite page), sweep the colour over the bottom of your paper to suggest fields. Use this same mix to reintroduce light areas within the bushes along the hedgerow. Allow to dry.

6 Use the rose madder, ultramarine and sap green mix on a rigger to draw in a fence in front of the large tree.

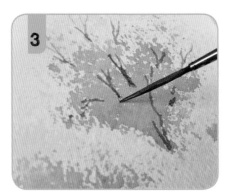

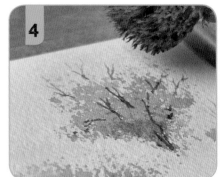

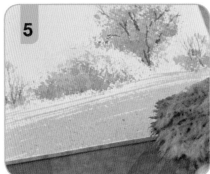

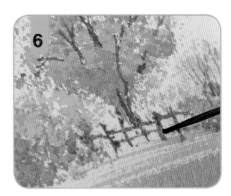

Foliage stamping

Stamping in foliage with a natural sponge is similar to stamping with any other item such as cardboard (see page 44). Pick up the paint with the sponge and dab it on the paper lightly to leave a little paint on the surface. The natural shape of the sponge will give you a foliage effect quickly and easily.

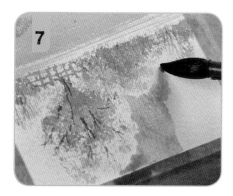

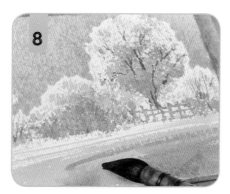

7 Turn your board 180 degrees around. Using the medium wash brush, negatively paint in a sky in cobalt blue.

8 Turn your board back to its original position. Apply a dry-brush effect across the foreground grass in cobalt blue, to complete the picture.

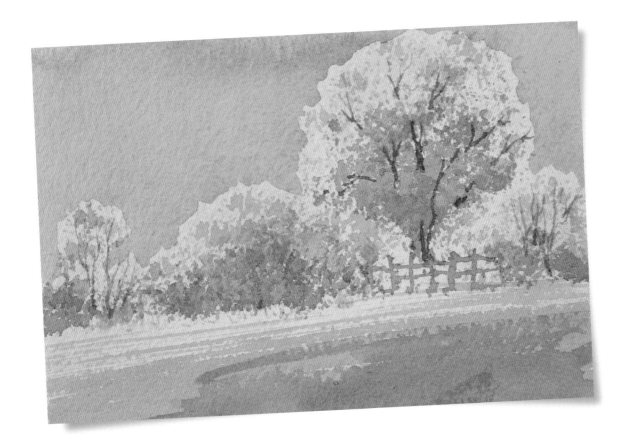

Technique: **Dry-brush**

This textural effect is useful for giving some depth to images, simplifying detail, such as tree bark or foliage, or depicting large areas filled with leaves or grass.

You can achieve the effect using a natural sponge, as seen in this study, or a rag (far right) but it is more commonly done with a brush (right). Begin with a damp brush loaded with only a little colour, and drag it lightly over a dry rough-surfaced paper to catch the raised texture of the paper.

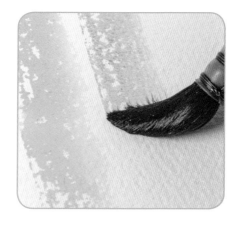

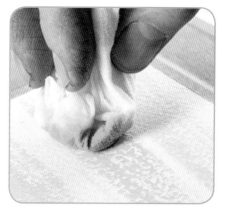

Summer tree

Creating the shape, colour and texture of summer trees can be difficult, but if you concentrate on the outline shape, texture and lights and darks using brush and rag, you can achieve some good results. This is a good exercise to learn how to exploit those green colour mixes.

YOU WILL NEED

Paint colours: ultramarine (green shade), lemon yellow, sap green, rose madder, cadmium yellow, burnt sienna

Brushes: medium wash brush, filbert, toothbrush, size 6 round

Other: rag, tracing number 16

1 Begin with a flat wash of ultramarine (green shade) laid with a medium wash brush. Lift out the tree area and the hillside at the rear of the scene with the damp rag, and allow to dry. Use a yellow-green mix of lemon yellow and sap green for the field to the left of where the tree will stand. Lift out the trunk area with the rag.

2 Mix ultramarine, rose madder and a touch of sap green; fill in an area of hedgerow behind the field. Soften the hedgerow with the rag, then darken the bottom edge with a stronger mix of the ultramarine, rose madder and sap green.

3 Use the dab and twist technique (see page 51) to give the tree its foliage using a mix of sap green, cadmium yellow and ultramarine on a small filbert. Leave a couple of gaps in the foliage to be filled at step 9 with branch detail.

4 Switching back to the wash brush, lay in a muddy field behind the tree in a mix of rose madder, cadmium yellow and cobalt blue. Paint in the negative shapes of the bushes and greenery in the very foreground.

5 Load a toothbrush with the mix used in the field, and flick some texture into the field area itself.

6 Lay in the first layer of the tree trunk and the branches visible through the gaps in the foliage, using a mix of cadmium yellow, rose madder and burnt sienna.

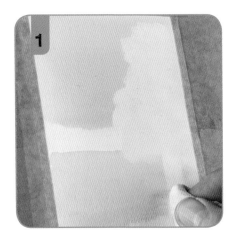

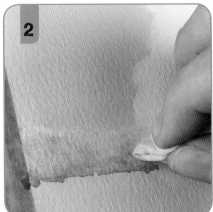

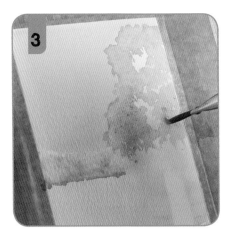

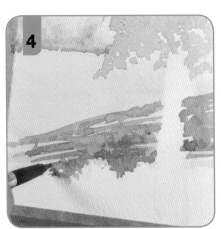

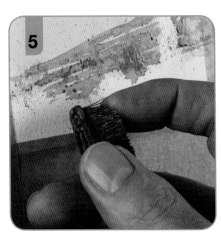

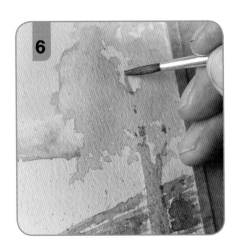

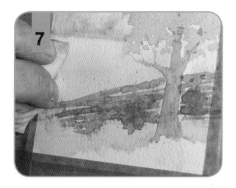

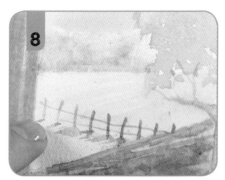

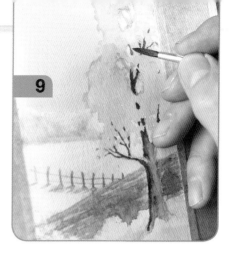

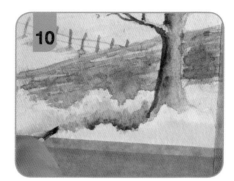

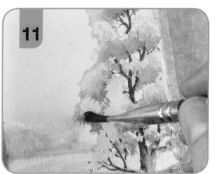

7 Run a layer of sap green across the foreground field, then, with a damp rag, soften the edge of the rear field to reintroduce light.

8 Turn the paper upside-down. With the size 6 brush, paint over the field behind the tree (painting negatively around the trunk) with a glaze of ultramarine. Turn the paper right-side up, and with a mix of ultramarine, rose madder and sap green, draw a line of fenceposts coming in from the left. Put in the shadows of the fenceposts in a mix of sap green and ultramarine, and draw out the shadows with your finger towards 'eight o'clock'.

9 Fill in the shadowed side of the trunk in a purple mix of ultramarine (green shade) with rose madder, imagining the sun coming from the top-right of the scene. Fill in the shadows on the undersides of the branches, and under the foliage.

10 Lay a yellow wash over the field in the background. Turn the paper upside-down again, and with a mix of sap green and ultramarine, negatively paint in the shapes of grasses in the foreground. Darken the mix with ultramarine to give the grasses some shadow.

11 Using the dab and twist technique again (see page 51), with the filbert, dot sap green with ultramarine over the foliage. Clean the brush then dab and twist with the damp brush to soften. Work down the tree from the top of the crown. Allow to dry, then dot in cadmium yellow among the grasses and the foliage to reintroduce light. Finally, use ultramarine to glaze over the field behind the tree, and a mix of sap green with ultramarine to redefine the edges of the foliage.

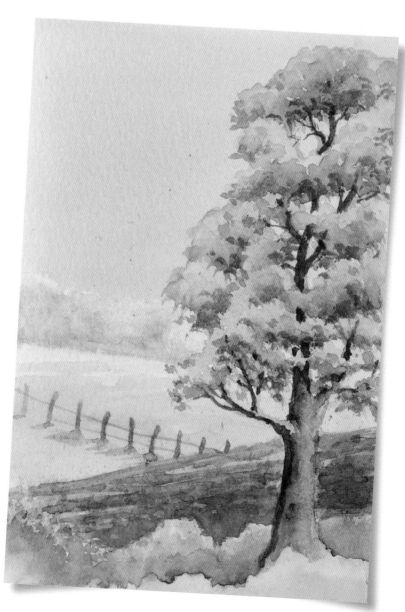

Autumn tree

YOU WILL NEED

Paint colours: ultramarine (green shade), cobalt blue, rose madder, sap green, burnt sienna, cadmium yellow, cadmium red

Brushes: small wash brush, sizes 2 and 4 riggers, filbert, sizes 2 and 4 round

Other: rag, tracing number 17

It's autumn time again, and time to marvel at those magnificent colours you can see in the trees! There is something majestic about the tree colours in autumn, but sadly this season doesn't last very long. Fortunately, you can preserve a little bit of autumn by painting an autumn tree of your own!

1 Begin with a flat wash laid in ultramarine (green shade) using a small wash brush; lift out the lower shapes of the land and the tree itself with the damp rag. The background bushes are created with a mix of cobalt blue, rose madder and a hint of sap green dabbed in with a loaded rag. Use the same dabbing technique to suggest a hill on the right-hand side of the scene.

2 Load the rag with burnt sienna on its own, and dab the rag along the lower half of the paper to represent ground foliage.

3 Mix ultramarine with burnt sienna and create the shape of a large tree trunk on the right-hand side of the paper with the size 4 rigger. Paint in the direction of growth. Use the same mix to dot in some brown foliage for a bush at the base of the tree, and the suggestion of fallen leaves on the ground. Use a dry-brush technique here, keeping the bristles of the brush splayed.

4 Switch to the size 2 rigger; glaze over the twigs to darken them, then bring them over and across the path.

5 Take up the filbert. Mix cadmium yellow and cadmium red for a bright orange and a reddish orange, in separate areas of your palette. Start by dabbing and twisting (see page 51) in cadmium yellow to create the first layer of foliage over the crown of the tree and at the tops of the bushes at the bottom of the scene. Repeat with the bright orange, going over the areas of yellow with the same dab and twist motion. Soften the foliage where necessary with a damp rag.

6 Go in over the foliage again with the reddish-orange mix, dabbing and twisting with the filbert over the crown of the tree and the foliage and path at the base. Allow to dry.

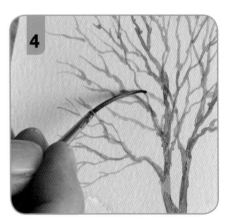

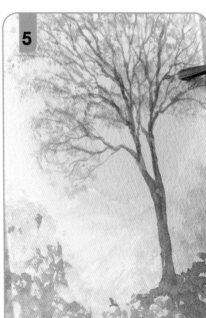

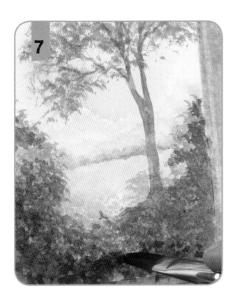

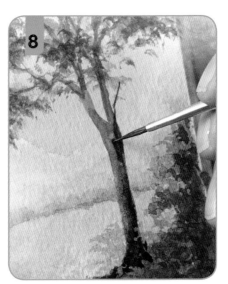

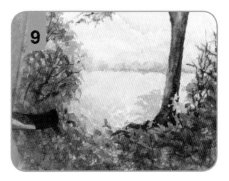

7 Take up cobalt blue on the size 4 round brush to put in the hedgerow using negative shape painting (see page 15). Soften the bottom edge with a damp rag. Then, dot cobalt blue into the shadowy areas of foliage at bottom of the paper with a thinner mix on the brush. Dab and twist the cobalt blue with the filbert into the lower areas of foliage. The blue, glazed over the yellow-orange mixes, will give different shades of green and brown. Dab and twist the cobalt blue into the crown of the tree in the same way.

8 Using a stronger mix of ultramarine (green shade), rose madder and sap green, dot in the details and shadow on the trunk. Go over the branches in the same way, darkening and blending the colours on the tree trunk. Use the same mix to negatively paint between the coloured foliage on the tree. Put some of the darks into the lower undergrowth to suggest the forms of the bushes, using the size 2 round brush.

9 Take up the filbert with the same dark mix, and dab and twist darker foliage at the top of the tree, glazing over the orange-red foliage areas. Finally, dab and twist in some more red areas (in rose madder) to complete the scene.

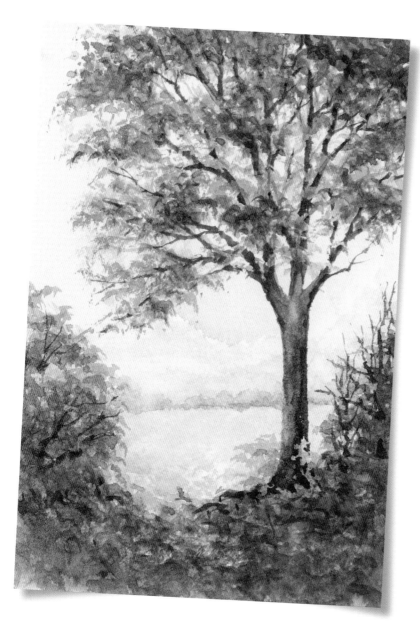

Winter trees

Winter trees are probably one of the most difficult elements to paint into landscapes. It is important that you understand their form and the way in which their branches grow. When painting a bare winter tree, make sure that the edges of a twig don't run straight and parallel to each other, and avoid painting twigs and branches that grow from either side of the same area on a tree trunk, thus making the tree appear unnaturally symmetrical.

1 Use the small wash brush to lay a very pale graded wash of cobalt blue from the top of the paper to the bottom. Lift out the land area with the rag. Once the graded wash is dry, scribble in the row of background bushes with the size 4 round and a purple mix of ultramarine and rose madder, muted with a touch of sap green. Wipe away the bottom edge of the hedges with the damp rag, and dab the area to soften it.

2 Use a pale wash of ultramarine to mark in the edge and shape of the bridge using the size 4 brush; soften with the damp rag.

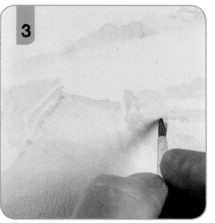

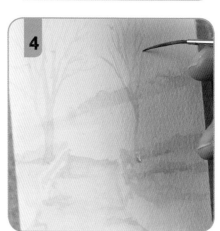

3 Still using ultramarine, mark in the position of the hedgerows on both sides of the bridge. Fill in the negative shapes around what will be railings on both sides of the bridge; using the pigment at the same consistency, paint or glaze over the driest area of the hedgerow to darken it. Soften these details with the damp rag.

4 Add a bare tree in the midground on the left, still using the ultramarine, on a rigger. Paint in the direction of tree growth. Do the same on the right of the bridge. Put in some dots among the twigs to represent leftover leaves, and smudge the ends of the branches with your finger.

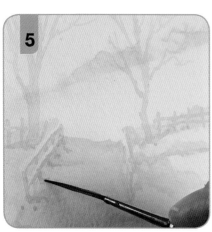

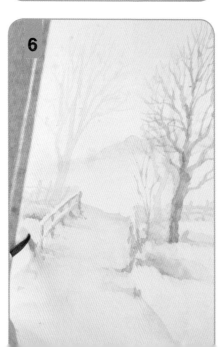

5 Paint in a fence line on the right-hand side of the bridge. On the left-hand side, fill in the dark areas on the railings.

6 Load a size 2 round brush with a mix of ultramarine (green shade) and rose madder; lay in a tree further forward on the right. Paint the trunk and branches in the direction of growth, then soften the ends with your finger. Paint the shadows on the snow in the same purple mix and soften with the damp rag. Add lots of shadow coming down from the railing on the right of the bridge, then darken the details on the left-hand railing and lay in its shadows. Fill in the shadows on the left-hand snow bank, then blend them with a soft brush.

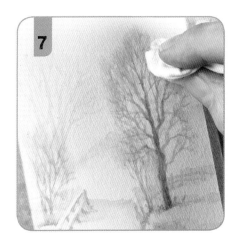

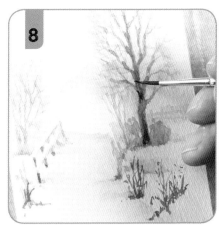

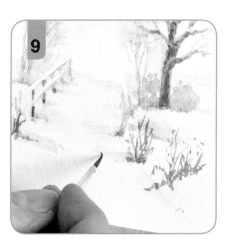

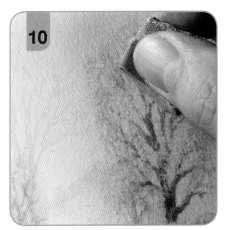

7 Dot in a small bush directly in front of the bare tree on the left-hand bank. Then grey the purple mix with sap green. Load the rag with the mix, and dot in small twigs on the foremost tree on the right.

8 Use the same grey mix on a size 2 round brush to strengthen the trunk of the tree on the right-hand bank and to dot in another, smaller bush at the foot of the tree. At this stage, bring in plenty of pigment: you will lose quite a lot when sanding the painting at step 10. Scribble in some tiny grasses coming through the snow in the foreground.

9 With a weak wash of cobalt blue, lay in some shadows on the snow across the bridge. Mark in the edges of the path coming down from the bridge, and soften these shadows with the damp rag. With the size 4 round, scribble in shadows on the edges of the path, on the banks and under the grasses. Allow to dry.

10 With sandpaper, rub over the tops of the trees to give them a frosty effect. Then go over the sanded areas with a putty eraser to remove the pigment and crisp up these areas.

Poppy field

In this study the background greenery is very soft and cool to avoid detracting from the importance of the poppies in the foreground. The poppies get smaller and closer together as they fade into the distance and the poppies in the foreground have more depth of colour and detail.

1 Using an applicator such as a colour shaper, dot in masking fluid for the poppies, beginning two-thirds of the way down the paper. Make the dots larger as you move towards the foreground. Draw in the poppies' stems as well.

2 Lay a graded purple-rose sky wash from the top of the paper down to the edge of the masked area, in ultramarine with rose madder. Soften the bottom edge of the wash with the damp rag, then, with a mix of sap green and cobalt blue, create a first line of bushes in the distance using the medium wash brush. Again, soften the bottom edge with the rag.

3 Paint around the poppies with a wash of cadmium yellow with a tiny hint of sap green. Then with sap green on its own, go in around the poppies wet-in-wet.

4 Add cobalt blue to sap green; run horizontal strokes back and forth (keeping the wash lighter over the top of the cobalt blue and sap green) to define the top edge of the field with a dry-brush technique before you lay in more bushes.

5 Lay some cobalt blue in the foreground in vertical strokes, then in the background in sweeping horizontal strokes. Dot in some darker details between the masked flowers.

6 While the flower areas dry, make up a light wash of cobalt blue and sap green and dot in to establish a hedgerow directly behind the poppy field. Soften with a damp brush. Leave an 'edge' at the top of this hedgerow to suggest layers of greenery behind, add more sap green to the mix and then establish the bushes at the far edge of the field with the size 4 round brush. Dot in ultramarine (green shade) for detail here and there.

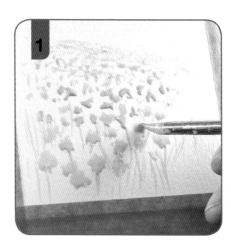
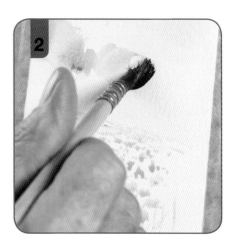
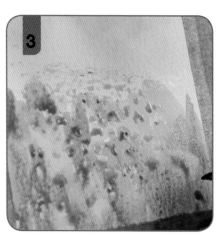
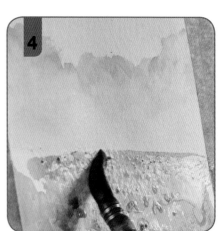
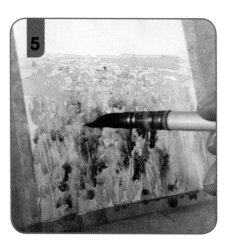
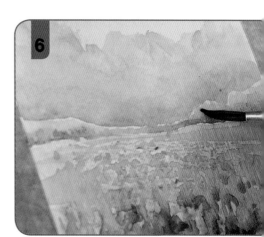

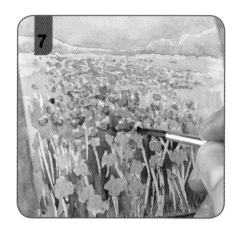

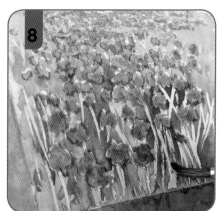

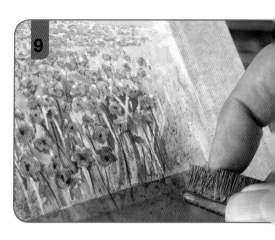

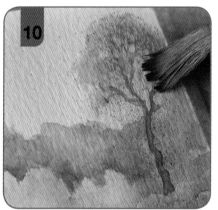

Technique: Splattering

Splattering involves drawing your finger or thumb over a brush such as a toothbrush loaded with paint. As your thumb runs over the bristles, dots and splatters of paint are flicked onto the surface of your paper.

Load the paint onto the side of the bristles, not the top, otherwise the paint will sink into the brush.

7 Rub the masking fluid away with your finger. With a pale wash of rose madder, dot in the poppy heads, beginning at the back of the field and moving forwards. Then, strengthen the rose madder and go back in again to give the flowers more depth and dimension. While the poppies dry, use negative shape painting in cobalt blue with rose madder to suggest the density of the bushes and trees at the rear of the field. Brush the colour down into the foremost bushes to give them more dimension.

8 Dot cadmium red onto the poppies to paint them a deeper red. Using a mix of lemon yellow and sap green, sweep in vertical strokes to fill in the grasses. Then, in a dark mix of ultramarine, rose madder and sap green, dot in the flower centres and stalks.

9 Load the toothbrush bristles with sap green and a touch of cobalt blue, and splatter this mix over the foreground of the scene to add texture (see technique above). Then dot in areas of cadmium yellow on the tip of the medium wash brush to reintroduce light.

10 The trunk of the tree in the background is painted using a rigger and a dark, but watered down, mix of ultramarine and sap green. Allow to dry, then dab and twist (see page 51) with a kolinsky filbert loaded with a sap green-ultramarine mix to fill in the foliage over the top edge of the tree. Dab with a 'broken' (splayed) brush, using the dry-brush technique. To finish the piece, switch back to the rigger, and go back over the branches and twigs in the same dark mix, using the mix also to paint in the simple fence line.

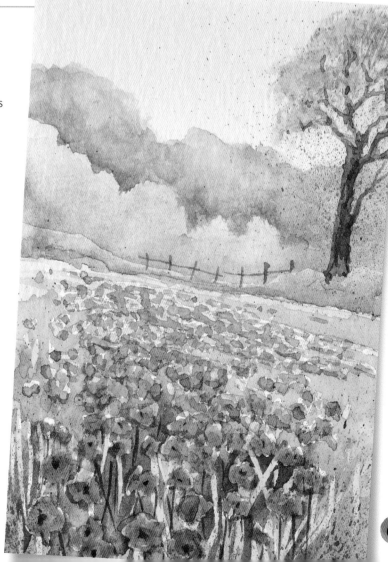

Wildflower patch

YOU WILL NEED

Paint colours: rose madder, ultramarine (green shade), sap green, cobalt blue, cadmium yellow

Brushes: small wash brush, size 4 round

Other: masking fluid, colour shaper, toothbrush, rag, tracing number 20

Wildflowers can be a rather difficult subject to paint due to the myriad variety of shape, size and hue on display, but with the use of masking fluid and good use of colour, your depiction of wildflowers can border on the abstract when applied with a loose and fluid touch to garner an effect that is both engaging and deceptively simple to achieve.

1 Begin by flicking masking fluid onto the paper with the toothbrush. Then use the colour shaper to dot in some larger marks here and there, at the tops and edges of the flicked area of fluid, to represent the larger flowers. Sweep in some vertical strokes for wild grasses.

2 Lay a wash of rose madder with ultramarine (green shade) from the top of the paper down to the masked area, then soften the bottom edges of the wash with a damp rag.

3 Create the suggestion of a tree line with a pale mix of sap green and cobalt blue. Again soften any harsh edges with the rag.

4 Strengthen the sap green and cobalt blue mix considerably. With the small wash brush, paint over the masked area in the foreground. Working wet-in-wet, mix the blue-green with sap green on its own. Paint negatively between the masked areas with a strengthened mix of the blue-green. Add highlights here and there with dots of cadmium yellow and sap green. Allow to dry.

5 Rub off the masking fluid with your finger.

6 With a weak mix of cobalt blue greyed slightly with sap green, lay in the loose shapes of trees in the far background with the size 4 round brush.

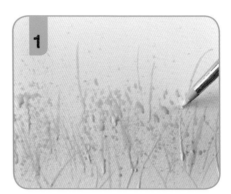

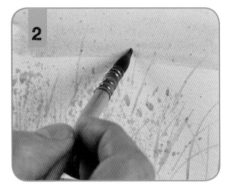

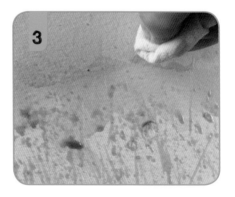

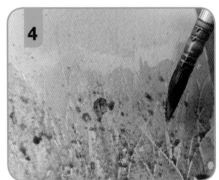

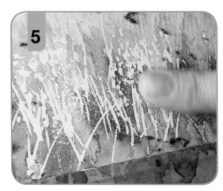

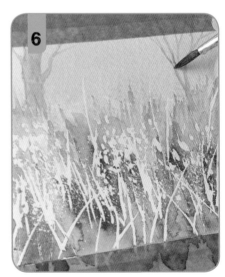

7 Dot in some flowerheads in fairly weak rose madder, then go back in with a stronger mix, making the second 'dots' lower than the first to suggest flower centres.

8 Repeat step 6 with ultramarine, dotting in the second, stronger mix lower than the first mix.

9 Dot in cadmium yellow in the same way.

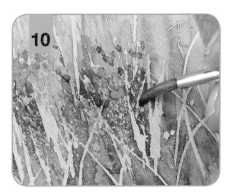

10 Mix a yellow-green from lemon yellow and sap green, and sweep in some grasses over the previously masked area. Keep the wash light at first, then overpaint with a darker mix. Use a darker mix of cobalt blue and sap green for the lower grasses.

11 Use the same cobalt blue and sap green mix to paint in the negative shapes between the flowers to add shadow; then, to complete, darken the background trees with a glaze of ultramarine (green shade).

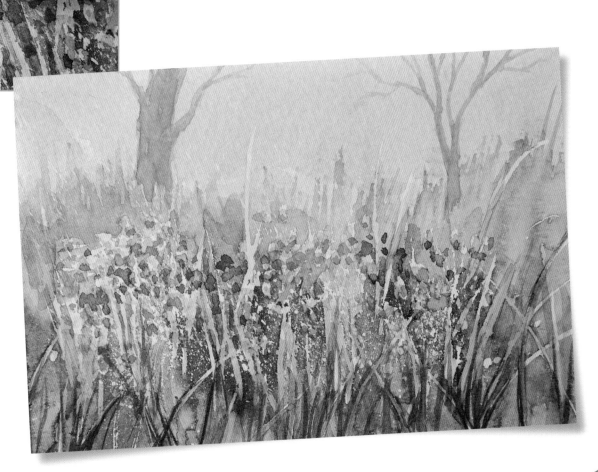

Paint colours: lemon yellow, cobalt blue, cadmium red, cadmium yellow, yellow ochre, sap green, rose madder

Brushes: size 6 round, large wash brush

Other: tracing number 21

Flowerbeds

If you have visited a public garden and wished you could capture the amazing array of flowers, but have dismissed the idea because of the effort and the time it would take to reproduce them all in a watercolour scene, rest assured. It is not necessary to paint every individual flower in a bed: you need only create an impression of a flowerbed without specific details.

Simplifying a scene

To help you look at a whole scene and note the main elements without absorbing too much detail, half-close or squint your eyes when assessing the scene. You will admit only the brightest rays of light, which has the effect of blurring the image and thus, very little detail can be discerned.

1 Paint in the shape of the first cluster of flowers in lemon yellow using the size 6 brush.

2 Load the brush with cobalt blue and dab in the colour, wet-in-wet, along the edges of the yellow areas.

3 Pick up some rose madder and use it to dab in between the yellow areas, and the areas adjacent to the cobalt blue flowers.

4 Mix cadmium yellow and cadmium red together and use the mix to dot in detail in the yellow areas of the flowerbed.

5 Load your brush with yellow ochre and sweep in the path area in front of the flowerbed. Use a dry-brush technique to give the path texture.

6 Make up a weak mix of sap green and cobalt blue to fill in the greens at the foot of the flowerbed in between the colour areas. Fill in the area behind the flowerbed as well; sweep in tall grasses behind the flowers. Your first layer of colour has been completed; the next layer of colour will be a glaze.

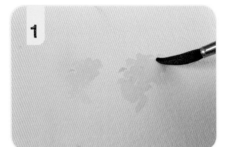
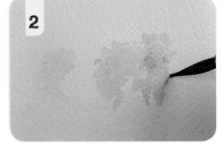
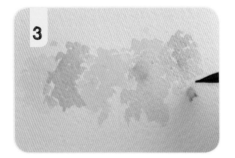
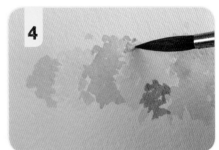
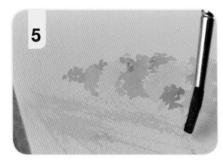
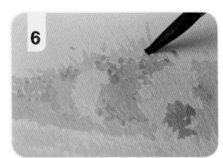

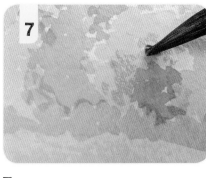

7 Starting with cadmium yellow, add shadows to the yellow flowers.

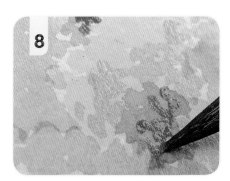

8 Take up the cadmium yellow-cadmium red mix and use this to strengthen the colours of the yellow flowers. Soften the colour as necessary.

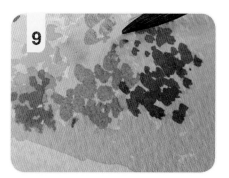

9 Make up a stronger mix of rose madder for the pink flowers, and a stronger cobalt blue to give shadow to the blue flowers.

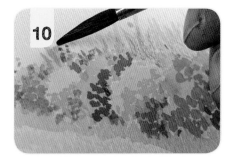

10 Sweep sap green on its own over the grasses and dab it in between the different coloured flowers.

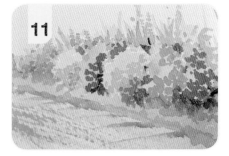

11 Sweep burnt sienna in over the yellow ochre to thicken the path alongside the flowerbeds. Mix sap green in with the burnt sienna: use the mix to fill in the shadows between the different flowers, and to draw out the shadows of flowers on the path.

12 Dab in the shadows directly under the flowers with cobalt blue and sap green, then finally sweep in the last shadows on the path with cobalt blue on its own, using the large wash brush.

WATER

Water is a useful element to paint into any landscape picture, especially when used as a mirror to reflect the colours in a sky, trees, buildings, or any object near the water's edge. The colours reflected in water are also affected by the colour of the water itself. For instance, if the water is clear, then the colours reflected in it will be very similar to those of the object itself. However, if the colour of the water appears green or brown, then the colour reflected will be distorted because it will have a little of the water's own colour mixed in.

Tree-Lined Brook,
25 x 35cm (9¾ x 13¾in)

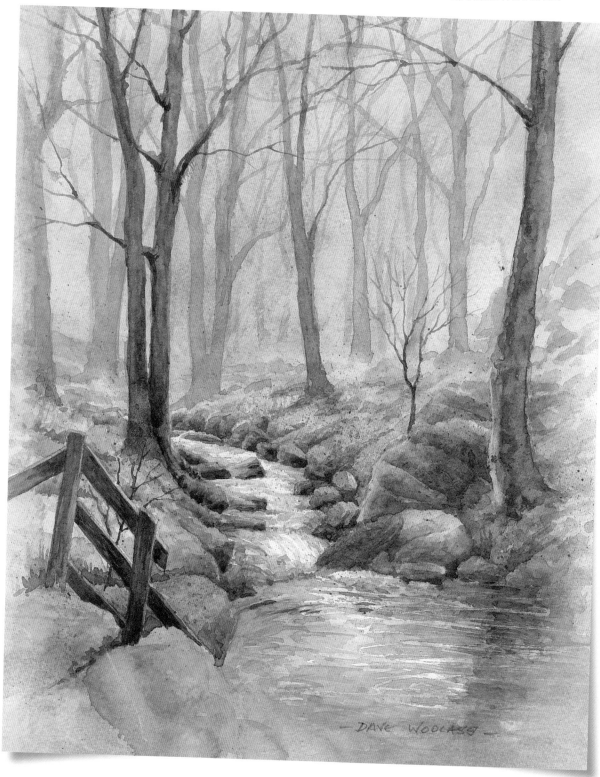

— DAVE WOOLASS —

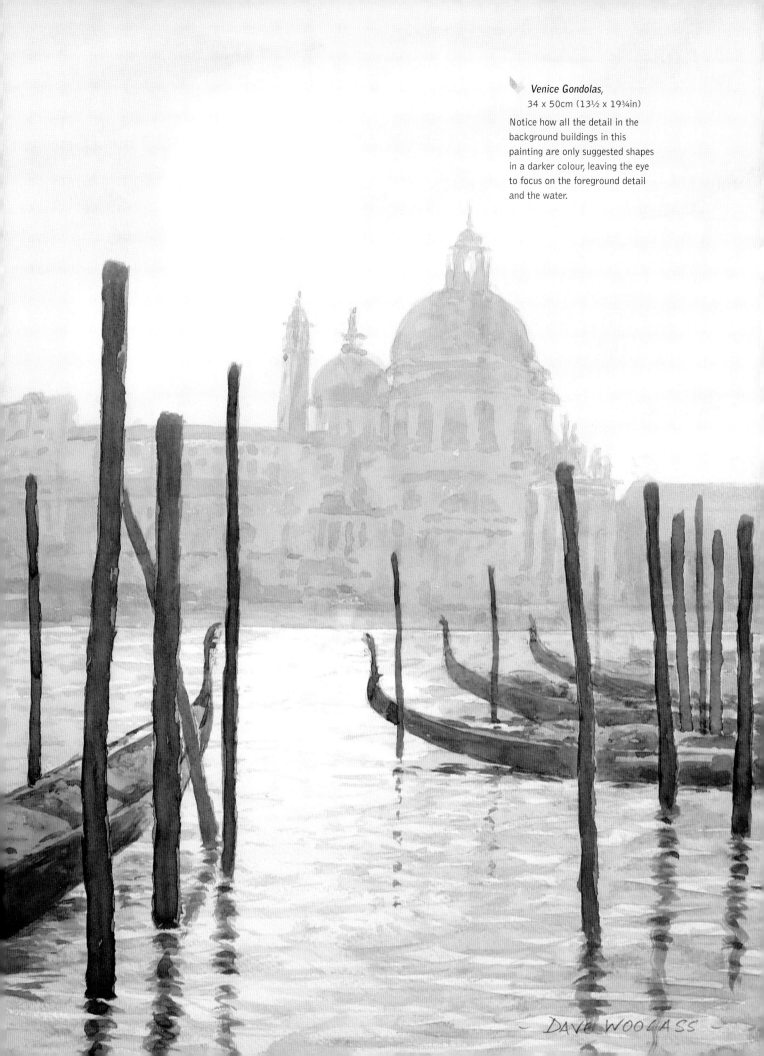

Venice Gondolas,
34 x 50cm (13½ x 19¾in)

Notice how all the detail in the background buildings in this painting are only suggested shapes in a darker colour, leaving the eye to focus on the foreground detail and the water.

— DAVE WOOLASS —

Giving water depth & sparkle

Watercolours are perfect for painting water due to their transparency and their natural interaction with water itself. Certain watercolour painting techniques can result in realistic water effects. These techniques, which include painting wet-in-wet, scratch-out and the use of plastic food wrap will help enhance your paintings of rivers, lakes and seascapes.

Technique: Using plastic food wrap

Do not leave the plastic wrap on for too long, as the paper will buckle underneath.

1 Make up a mix of ultramarine (green shade) and sap green. Lay a wash of ultramarine (green shade) on the paper first, then lay in the mix of ultramarine with sap green, wet-in-wet below it.

2 While the paint is still wet, stretch a torn-off sheet of plastic food wrap slightly, and lay it over the top of the wash to form ripples in the water. Allow the paint to dry, then remove the plastic wrap.

3 Lay in a new wash of the ultramarine-sap green mix at the bottom of the water area.

4 Replace the plastic wrap over the wash.

PUTTING IT INTO PRACTICE

Once your wash has dried, and you have removed the plastic food wrap again to reveal natural-looking ripples, there are several ways in which you can add depth and sparkle to the water's surface. Try these techniques to create your own streamside scene, using tracing number 22 as your basis.

Adding highlights

Fresh water generally lies flat, so it's a good idea to paint the larger areas with a wash, then recreate the ripples and highlights with horizontal strokes and reflections with vertical strokes.

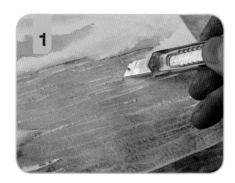

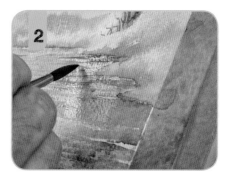

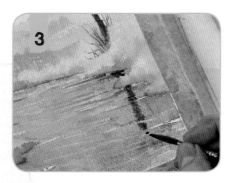

1 With a craft knife, scratch out areas of light and sparkles of sunlight on the surface of the water.

2 Mix sap green and ultramarine (green shade) with a size 6 round brush, and fill in some of the darker ripples on the water for contrast.

3 Mix burnt sienna with ultramarine (green shade). Paint clear water over the surface of the water area. While it is still glistening, go in with the burnt sienna-ultramarine mix to dab in the reflection of a tree, wet-in-wet. Soften the reflection with a damp rag.

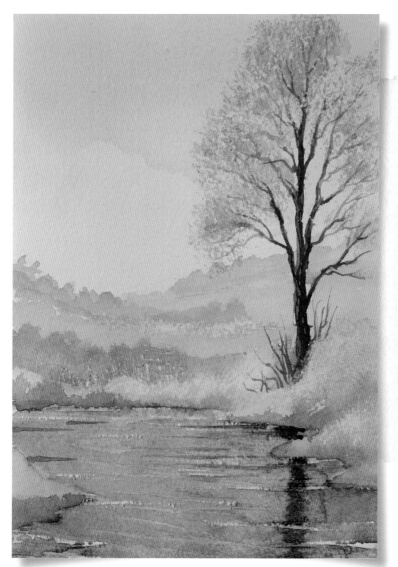

A gallery of special effects

The foliage on the tree at the streamside has been dabbed in using the natural sponge (see pages 52–53); the grasses at the water's edge at the centre of the painting have been gently scratched in using sandpaper. Rough sandpaper is better – 120 grit, for instance – rub the paper lightly to scratch out the grasses.

Boat on open water

YOU WILL NEED

Paint colours: ultramarine (green shade), rose madder, sap green

Brushes: small and medium wash brushes, sizes 2 and 4 round, rigger

Other: masking fluid, colour shaper, toothbrush, low-tack masking tape, craft knife, putty eraser, tracing number 23

Painting open water can be a fairly complex subject, and many artists struggle to create the effect of sunlight sparkling across the water. This study demonstrates how you can use masking fluid and the scratch-out technique to represent this dazzling effect.

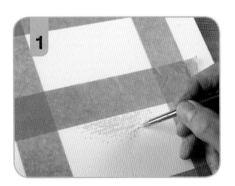
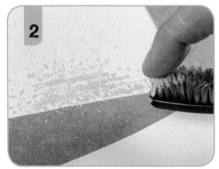

1 Stick a strip of low-tack masking tape horizontally across the middle of your paper. Use an applicator to dot in masking fluid below the line of the tape – this is where the sparkle of light will fall on the water. Pull the masking fluid horizontally in places and allow the shape to taper off as you move down the paper.

2 Turn your paper upside-down. Flick more masking fluid over the same area with a toothbrush. Allow to dry.

3 Turn the paper back the right way round and remove the masking tape. Load a medium wash brush with ultramarine and lay a graded wash from the top of the masked area to the bottom of the paper. Allow to dry.

4 Lay a graded wash in weak ultramarine from the top of the paper as far as the horizon line. Allow to dry.

5 Turn your paper upside-down again. With a mix of ultramarine and rose madder, lay a slightly graded wash from the top (bottom) of the paper to the horizon line, glazing over the original wash. Allow to dry.

6 Rub off the masking fluid with your finger.

7 Mix ultramarine with rose madder, and grey the mix with a touch of sap green. Use this mix to paint in the shape of the body of the boat with the size 4 round brush, applying a flat wash. Leave a line of light between the hull, and the mast and sails. As the mix dries, go back in and lay another flat wash over the boat. This glaze will make the colour darker.

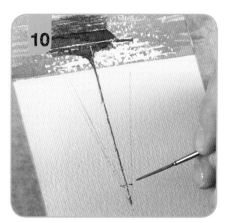

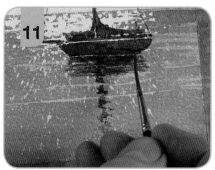

8 Start painting in the reflection of the boat in the ultramarine-rose madder mix. Paint the reflection between the ripples suggested in the water with the size 2 round brush.

9 Paint the mast in an incomplete line in the same mix.

10 Use a rigger to fill in the dark areas on the mast, and then to paint in the rigging: you may wish to turn your paper upside-down again in order to do this. Paint in the horizontal bar at the top of the mast.

11 Paint in the reflection of the mast on the water with the rigger: thin out the colour towards the bottom of the paper. Strengthen some of the reflection under the boat with the same mix.

12 With a craft knife, scratch out some additional sparkles on the water, picking out some of the masked areas. Finally, go back over the scratched-out areas with a putty eraser to remove the loose pigment.

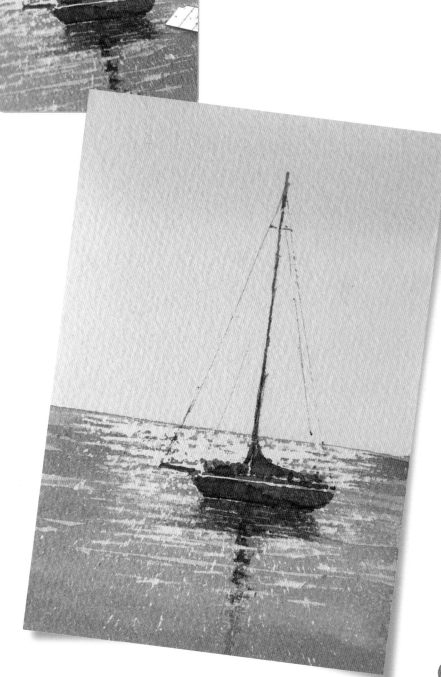

Paint colours: ultramarine (green shade), sap green, lemon yellow, cadmium yellow, rose madder, burnt sienna

Brushes: size 8 round, medium wash brush

Other: palette knife, rag, craft knife, putty eraser, tracing number 24

Waterfall

When you are painting moving water, such as in this study of a woodland waterfall, careful study of what you actually see – rather than what you think you see – will help you to create a more realistic effect.

The scratch-out and scraping technique has been used in this study to suggest the texture of the rocks and the highlights in the water.

1 Paint in the rocks first in a mix of ultramarine and sap green, using the size 8 round brush. Suggest the curve of the falling water with the positions of the rocks. Use the tip of a palette knife to draw out the colour from, and add texture to, the tops of the rocks. Paint a little shadow and ground texture around the bases of the rocks. Then, using the same ultramarine-sap green mix, draw in the vertical strokes of the individual 'steps' of the waterfall.

2 With watered-down ultramarine, apply a pale graded wash for the sky, still using the size 8 round brush. Dab a rag into the ultramarine-sap green mix and, working wet-in-wet, dot in some greenery behind the waterfall.

3 Make up a yellow-green mix of lemon yellow and sap green, and reinforce the greenery around the top of the waterfall and around the edges of the rocks. Soften with a damp rag, then, still using the yellow-green, establish some grass detail around the edges of the waterfall with a medium wash brush.

4 Working in the direction of growth (from the ground upwards), paint in the suggestion of distant trees in the background on the left of the scene, using ultramarine with a tiny hint of sap green. Use a mix of cadmium yellow with rose madder and ultramarine to lay in the trunk of a tree in the midground on the left bank. Darken the same mix and glaze over the trunk to define the details. Repeat to paint in two trees on the right-hand bank.

5 Lift out the tops of the rocks with a damp rag to soften them, then allow to dry. Use a mix of rose madder, cadmium yellow and a touch of burnt sienna over the foreground trees on both banks. Add some of this same mix as a glaze on the rocks.

6 Using ultramarine (green shade), colour in the water in horizontal strokes starting from the foreground and moving back. Paint in the flat tops of each step of the waterfall.

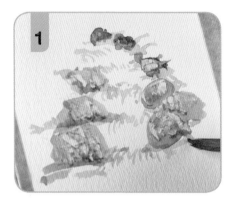

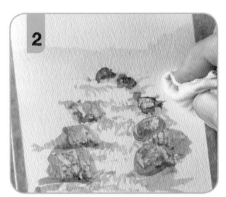

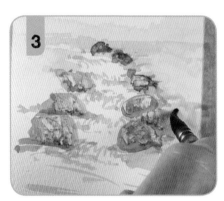

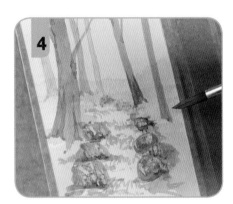

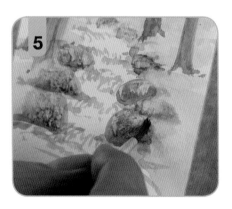

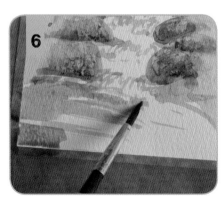

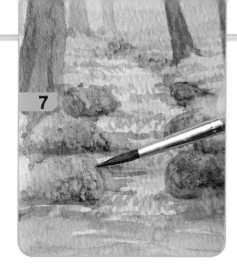

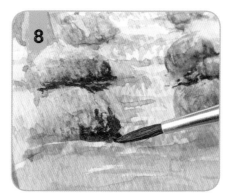

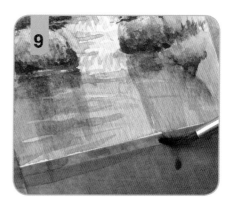

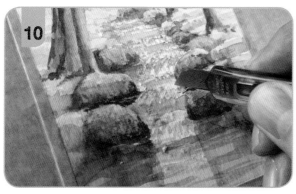

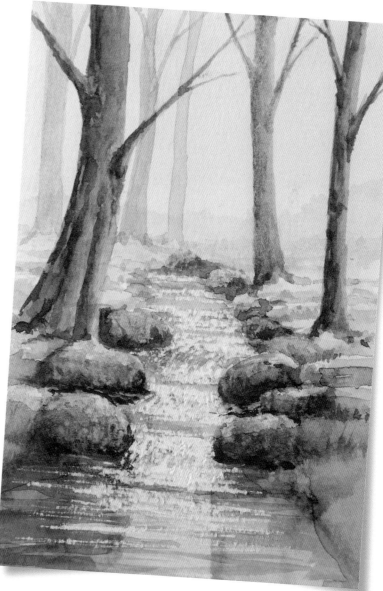

7 Use the mix from step 6 to define the hedgerows in the rear of the scene, to fill in the shadows in the bank alongside the waterfall and at the base of the trees. Then, using downward vertical strokes, fill in the 'falls' themselves, still using the ultramarine.

8 Mix ultramarine and rose madder, and grey with sap green; touch in some stronger darks at the bottoms of the rocks to enhance the light on the front of each rock. Allow to dry. Lay a flat wash of sap green onto the water's edge and onto the trees as a glaze and allow to dry. Add more sap green onto the rocks in the mid- and foreground.

9 With a purple mix of ultramarine and rose madder, fill in the dark details of the trees. Blend them with a damp brush. Use the same purple mix to stroke in the dark areas in the grass especially between the rocks at the bank. Add a little sap green to the purple mix and dot in colour around the bottom of the foreground rocks and along the water's edge. Dilute the mix and use to pull the reflections of the rocks down into the water in the foreground. Use the rag to soften the background trees, and a damp brush to soften the reflections of the rocks. Glaze the falls and the water area with a mix of ultramarine and sap green.

10 With a craft knife make horizontal scratches on each 'step' of the waterfall to take up the paint and create sparkles. Scratch away from the rocks on each side of the water. At the base of the waterfall make the scratches wider to represent the water splashing down and pooling. Finally, rub over the scratched areas with the putty eraser to take the colour out of the paint and make the sparkles appear brighter.

THE LIVING LANDSCAPE

The option of adding human figures or animals into a landscape is one that every painter should consider, as these details can make the difference between an ordinary painting and an outstanding one. A viewer identifies with figures or animals in a painting; the eye is drawn to them.

FIGURES AND ANIMALS

Figures in a landscape are essentially stick figures: the trick is to paint human figures and animals as loosely and simply as possible whilst retaining their overall natural shape. We recognise figures and animals not by any detail but by their outline. Keen observation is key, especially when depicting animals, to ensure that you paint their shape and do not worry about the details.

When painting human figures, their clothing needs to be brighter than the area into which the figures are placed. You will also need to relate the size of the figure to their surroundings – trees, or the doors and windows on nearby buildings. Try to paint people walking towards or away from the viewer, and vary the placement of your figures and animals to help create depth.

Afternoon Cricket,
35.5 x 19.5cm (14 x 7¾in)

Look closely at the trees; the textured effect has been created using salt.

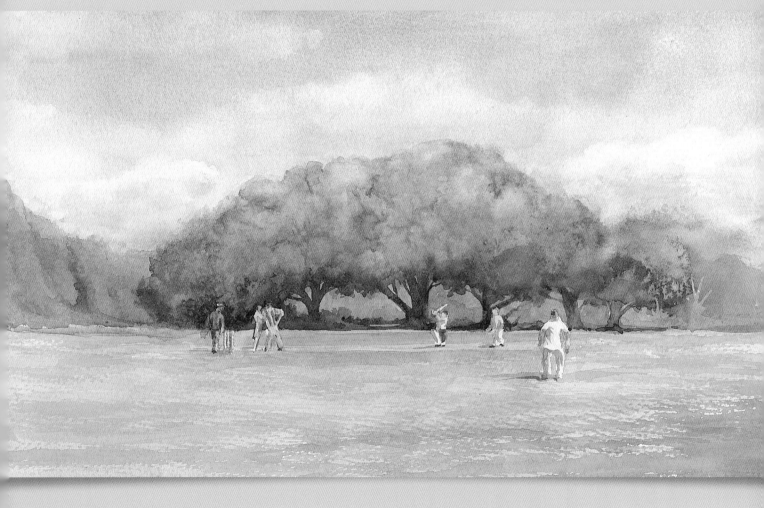

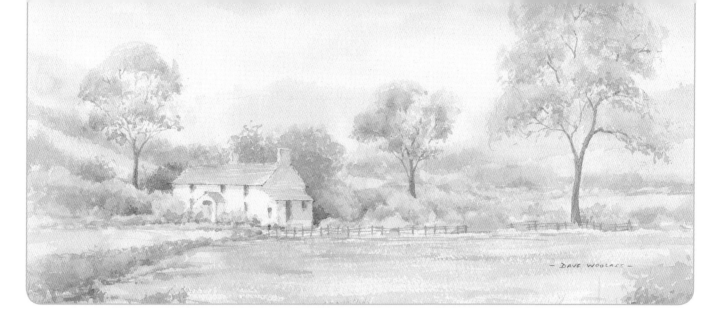

STRUCTURES AND BUILDINGS

Buildings within landscapes are among the most popular themes for artists: viewers readily identify themselves with these paintings because buildings are usually part of their environment – buildings remind the viewer of particular places and their associated memories.

Most of the buildings you paint will feature straight lines; but including too many straight lines inevitably results in the viewer's eye moving too quickly over the building. The viewer will subconsciously follow the straight lines back and forth. To slow down the movement of the viewer's eye, the artist should break up and change the appearance of any straight edge by painting an uneven line that is artistically more pleasing. The best way to break up some of these straight lines and edges is by including flowers, plants, bushes and even trees at various points so as to interrupt the visual straight edge.

 Uncle Peter's House,
50 x 24cm (19¾ x 9½in)

Pale delicate colours were used for most of this painting, leaving the more intense areas of contrast around the house, to make the building the focal point.

 Early Morning Meadow,
25 x 15cm (19¾ x 6in)

A fairly simple scene with buildings. Note how movement has been added with the inclusion of birds in the sky.

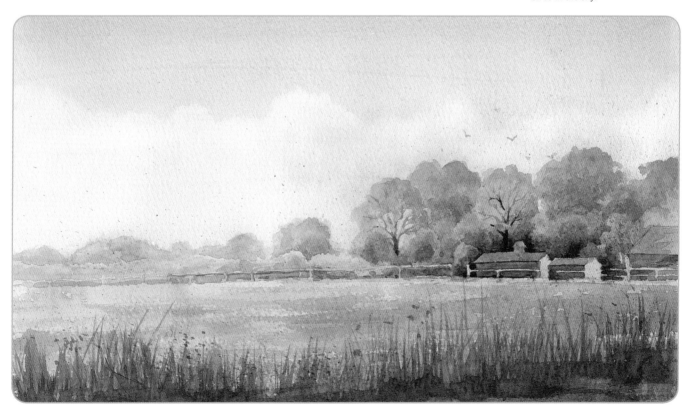

Paint colours: rose madder, cobalt blue, lemon yellow, sap green, yellow ochre, ultramarine (green shade), cadmium yellow, cerulean blue

Brushes: size 6 long round

Other: rag, tracing number 25

The rambler

Putting a figure into a landscape will bring movement into what could otherwise prove to be a static scene.

Here, I have chosen a very simple painting of a hillside path, into which I have added a rambling figure for interest.

1 Create a hillside with a size 6 long round brush, in a mix of rose madder and cobalt blue with lemon yellow to grey the mix. Soften the bottom edge of the hillside with a damp rag, but keep the top edge sharp.

2 Make up a grey mix of ultramarine (green shade), sap green and rose madder, and create a second hillside area in the nearer distance using the size 6 brush. Soften the bottom edges with the damp rag again.

3 Add a little more sap green to the grey mix, and lay in the hill details in the foreground. Create hedgerows on either edge of a path, with some foliage details running down the path itself. Soften in places, lifting out colour with the rag to reintroduce light, then allow to dry.

4 Load yellow ochre onto the brush, and run the colour into the path as an earth tone. Soften the edges of the path with the damp rag, then allow to dry again.

5 Take up the grey mix of ultramarine (green shade), sap green and rose madder, and draw in the trousers of a figure in the middle distance. Shorten one leg to make it look as if he is walking away. Dampen the tip of the brush, then sweep in a shadow by pulling away some of the grey colour from the trousers across the path.

6 Dab in rose madder and cadmium yellow for details in the foreground along the path.

7 Fill in the shape of the rambler's jumper with cerulean blue.

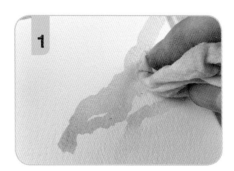

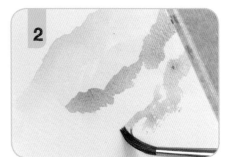

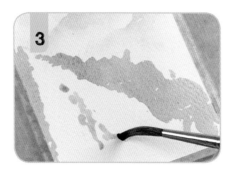

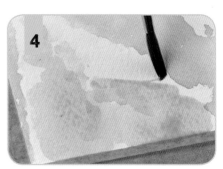

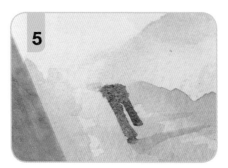

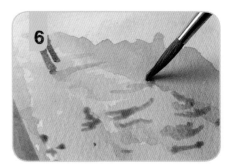

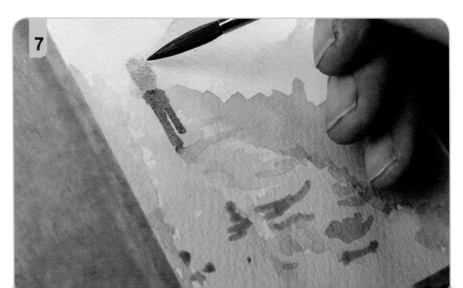

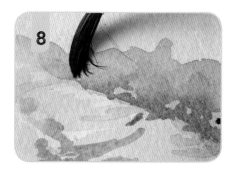

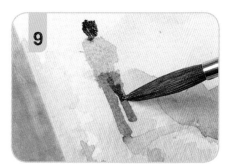

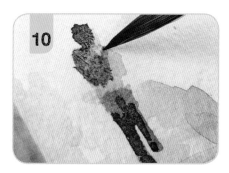

8 Make up a dark green mix with sap green and a little ultramarine (green shade) to darken the details along the hedgerow and the path. Use a damp brush to blend the darker green into the hedgerow.

9 Darken the grey mix from step 2 and use the darker mix to fill in the rambler's hair, and to give his trousers some shadow.

10 Make up a pale-flesh-coloured mix of rose madder and cadmium yellow and lay in on the right side of the rambler's face, to suggest he is looking to the side. Dot in a hand as well. Then, with the mix of sap green and ultramarine (green shade), give the figure a backpack.

11 Finally, reinforce the rambler's shadow by dotting in a rose madder-cobalt blue mix along the path.

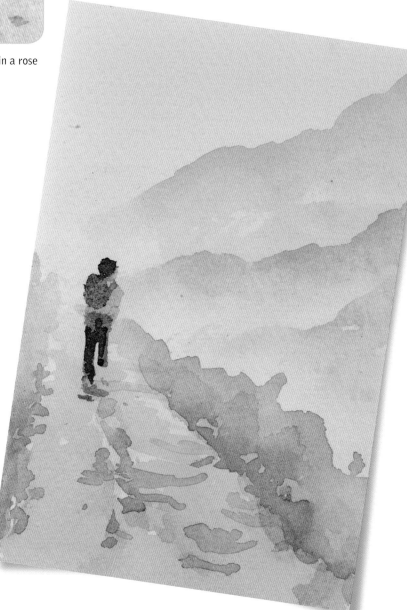

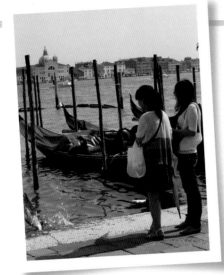

Watching the gondolas

Sometimes when we paint a scene from a photograph, such as the one shown on the left, we try to feature too much detail. This can make it difficult to keep a scene fresh and spontaneous. It is best to simplify the details in the background, and focus on overall outlines, shapes and colours.

YOU WILL NEED

Paint colours: cobalt blue, cerulean blue, rose madder, cadmium yellow, yellow ochre, burnt sienna; ultramarine (green shade)

Brushes: medium wash brush, size 6 long round, hog-hair bristle brush

Other: rag, card for stamping, tracing number 26

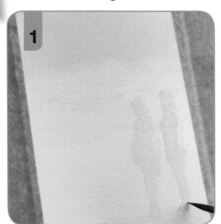

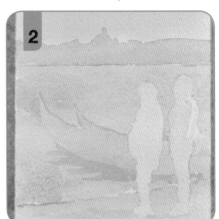

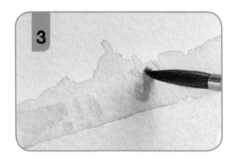

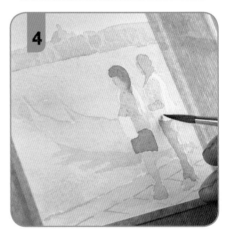

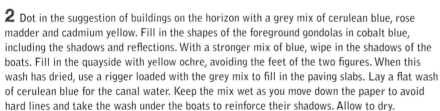

1 Lay in a flat wash of cobalt blue at the top of the paper with the medium wash brush, then soften the hard edge with the damp rag. With the size 6 brush, create the whole overall shape of the figures, apart from the areas on their backs that are cast in light. Use a weak wash of cobalt blue here to depict the shadows on their bodies and to avoid granulation. Wipe cast shadows across from their feet, right to left. Allow to dry.

2 Dot in the suggestion of buildings on the horizon with a grey mix of cerulean blue, rose madder and cadmium yellow. Fill in the shapes of the foreground gondolas in cobalt blue, including the shadows and reflections. With a stronger mix of blue, wipe in the shadows of the boats. Fill in the quayside with yellow ochre, avoiding the feet of the two figures. When this wash has dried, use a rigger loaded with the grey mix to fill in the paving slabs. Lay a flat wash of cerulean blue for the canal water. Keep the mix wet as you move down the paper to avoid hard lines and take the wash under the boats to reinforce their shadows. Allow to dry.

3 Suggest the details on the buildings in a darker shade of cerulean blue.

4 Use the size 6 brush to add the hair and trousers on the girl on the right with the grey mix. Add ultramarine (green shade) to the mix for the skirt and hair of the girl on the left. Paint exposed skin with pale burnt sienna, and the t-shirts with cerulean blue. Avoid painting over the highlights on their backs. Fill in the left-hand girl's bag with cerulean blue, and soften the colour with a hog-hair brush. Use cerulean blue to glaze the shadows to increase the value of the colour.

5 Use cerulean blue to represent the first layer of ripples in the water. Ensure the mix looks darker as you move towards the foreground and the quayside. Mix cerulean blue with a little rose madder and sap green, and stamp in the masts of suggested gondolas in the background using the short edge of a small rectangle of card (see page 44). Soften the bottoms of the masts with the damp rag.

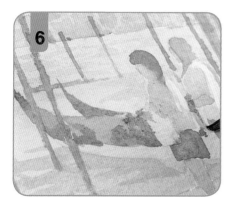

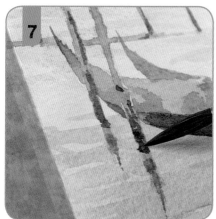

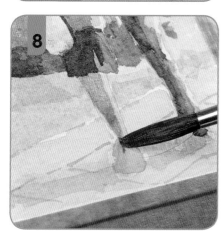

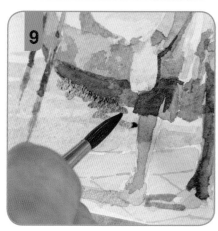

6 Take up the size 6 brush again: fill in the inside of the foremost gondola with a mix of cobalt blue and cerulean blue to define its individual shape. Then add rose madder to the mix and fill in the shadowy parts of the gondola. Repeat for the gondola behind it.

7 Mix burnt sienna and ultramarine into a grey and use to fill in the dark areas on both girls' hair, and the shadows on their skirt and trousers; dot in shadows on the left-hand girl's bag and both girls' shoulders (leave the sunlit areas clean), then fill in the dark areas on the bottoms of the foremost gondolas and allow to dry. Touch up the dark areas on the poles: keep them darker nearer the water to suggest they are submerged. Soften the shadows of the poles with the stiff, hog-hair bristle brush. Allow to dry.

8 To fill in the shadows on the girls' legs mix cadmium yellow and rose madder, with cerulean blue to cool. Draw the colour down the legs towards the feet, then add shadow in the same mix on the arms and faces. Mix in some more rose madder and add this as a glaze to the shadow areas on the figures to strengthen them. Use ultramarine (green shade) to enhance the figures' shadows on the quayside.

9 Darken the bottom of the boat with a mix of burnt sienna and ultramarine. Run the shadow along the bottom of the boat and dot the suggestion of the boats' shadows in over the ripples on the water. Complete the image with the suggestion of birds in the sky using the rigger loaded with rose madder and ultramarine. These need only be v-shapes to represent movement in the sky.

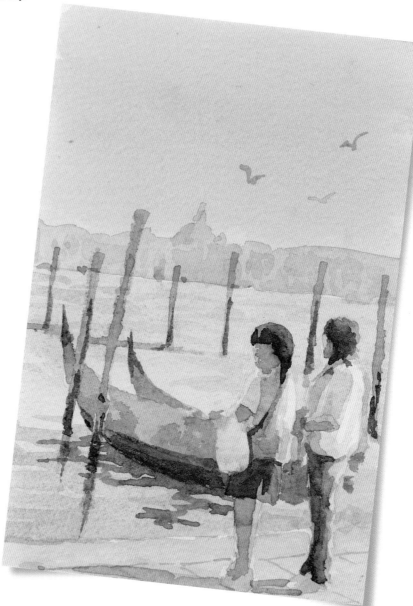

Distant sheep

The sheep in this study are represented as if in the far distance, and thus are quite subdued. If you want your sheep to stand out, create their shapes with masking fluid before laying the sap green wash, to make their forms brighter.

1 Sweep the sap green loosely across the paper using the medium wash brush and allow to dry before using the stiff brush to lift out the shapes of the sheep.

2 Next, dab the paint with a damp rag to lift out more of the colour, then allow to dry again.

3 Switch to the rigger. Dot in the faces and legs of the sheep in a dark mix of burnt sienna and ultramarine (green shade).

4 Dampen the size 6 brush and use it to soften the features of the sheep. Allow the painting to dry slightly.

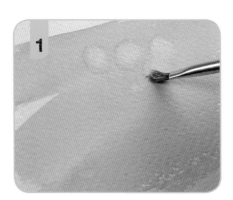

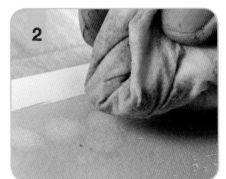

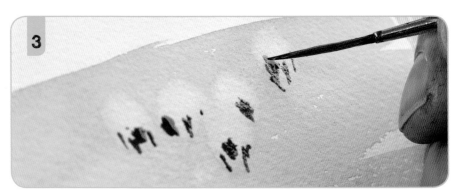

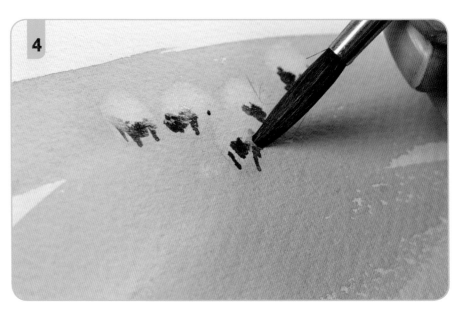

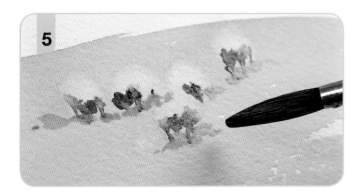

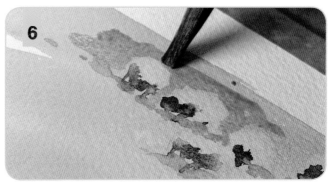

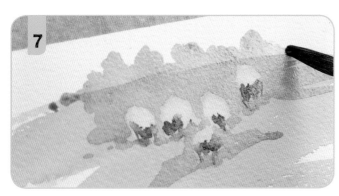

5 In cobalt blue, drop in the shadows of the sheep.

6 Turn your board upside-down. Paint around the sheep with sap green to define the hills around them negatively.

7 Turn your board back round again and dot in some trees and bushes on the hilltops. Allow to dry, then, to complete, dot in a mix of sap green and cobalt blue along the tree line to indicate dark shadows.

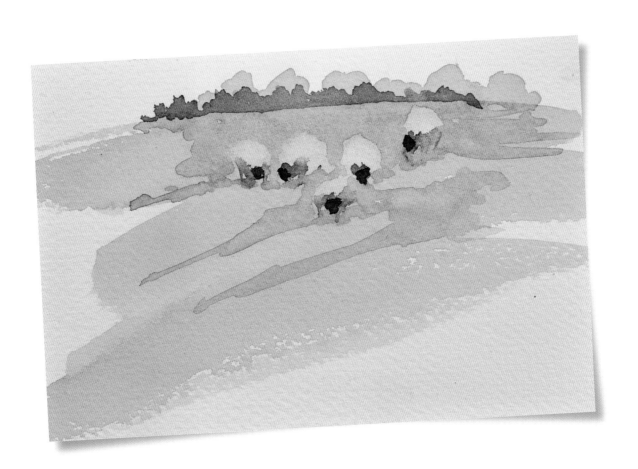

Paint colours: ultramarine (green shade), rose madder, sap green, burnt sienna, cobalt blue, cadmium yellow

Brushes: small wash brush, sizes 2 and 4 round

Other: plastic food wrap, rag, craft knife, putty eraser, colour shaper, tracing number 27

Dry-stone bridge

Elements such as a quaint old stone bridge provide an appealing focal point in a painting, with plenty of interesting detail. It could take you hours to approximate the texture of the stones with a brush; however, the effect here can be created quickly with plastic food wrap and a palette knife.

This project begins with a light graded wash in ultramarine (green shade), with the distant hills worked in a colourful grey mix of ultramarine (green shade), rose madder and sap green. The background hedgerow is laid in a mix of ultramarine (green shade) with sap green.

1 Outline the bridge in a mix of ultramarine (green shade) and sap green, then define the underside of the bridge in a mix of ultramarine, rose madder and sap green.

2 Use the same grey mix to fill in the rocks on the right-hand side of the bridge. Define their shapes with the edge of a palette knife. Fill in the river in the foreground with a diluted mix of the grey, then pull down the reflection of the underside of the bridge.

3 Use sap green to fill in the grassy areas in front of the bridge. Mix with cadmium yellow to fill in the grass on the underside of the bridge and the opposite bank. Allow to dry.

4 Paint the bridge with a mix of burnt sienna and ultramarine (green shade), applying the colour with a small wash brush, then apply plastic food wrap over the paint. Pat it into place with a colour shaper, and remove the plastic food wrap once dry.

5 With a damp rag, lift out some of the darker areas of the bridge and the rocks to suggest texture, and allow to dry again.

6 Make up a purple mix of ultramarine (green shade) and rose madder to fill in the brickwork details using a size 2 round brush. Follow the curve of the bridge and pick out the natural shapes made by the plastic wrap.

7 Mix cobalt blue and cadmium yellow and go into the hedgerows with negative shape painting to create the illusion of bushes, using a size 4 round brush.

8 Fill in the greenery to the left of the bridge in sap green with cobalt blue, and sap green on its own in the foreground and directly behind the bridge. Switch to a mix of ultramarine and burnt sienna to fill in the colour on the inner wall of the bridge. Add some purple wet-in-wet to reinforce the wall of the bridge, but leave a light edge on both top edges of the bridge.

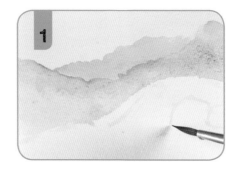
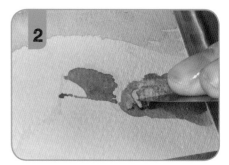
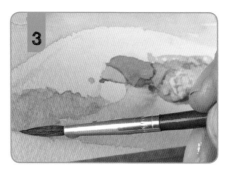

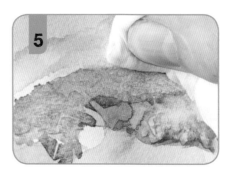
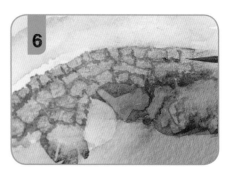
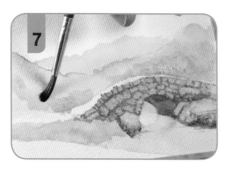
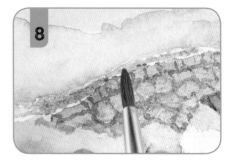

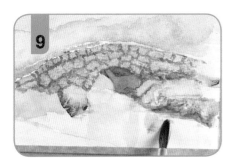 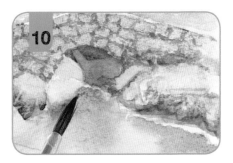 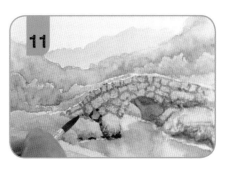

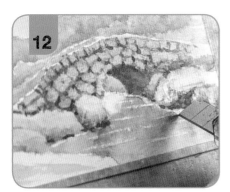

9 Rewet the river area. Lay in the reflections of the riverbanks behind the bridge with a tiny amount of sap green coming from under the bridge. Pull the colour down beneath the bridge, then return to the purple mix (ultramarine and rose madder) to fill in the reflection of the rocks on the right-hand bank. Leave a light edge directly under the bank.

10 Fill in the reflection of the bridge in the purple mix, then dot in some greens to suggest the reflections of the grassy banks.

11 Use a variety of blue-green mixes including sap green, ultramarine (green shade) and cobalt blue, used wet-in-wet, to create interest and density in the bushes and foliage around the bridge. Move down to the riverbanks in the same foliage mixes, but leave an edge of light on the water itself. In a thicker mix of sap green use a dry-brush technique (page 53) to sweep in a layer of texture in the foreground and on the right-hand riverbank. Pick out the very dark areas around the water's edge and in the brickwork in ultramarine, rose madder and sap green.

12 In the same dark mix, reinforce the reflections of the bridge – wet-into-wet – in downward strokes, and blend down. Use a craft knife to make horizontal scratches, starting under the bridge and moving forwards. Work away from the rocks and banks on both sides, then scratch some texture and light into the rocks. Soften the scratches with the putty eraser to complete.

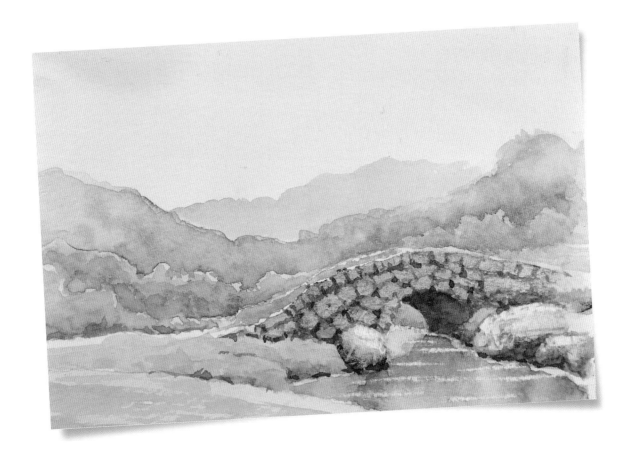

Farm building

This traditional farmland scene comprises large trees, a clear sky and bales of hay, all of which create interest with their assorted shapes and colours, and capture a sense of openness, whilst also showing the effect of sunlight on a landscape.

YOU WILL NEED

Paint colours: ultramarine (green shade), yellow ochre, lemon yellow, sap green, cobalt blue, rose madder, cadmium red, cadmium yellow

Brushes: medium wash brush, size 6 round

Other: rag, tracing number 28

1 Lay a graded wash in ultramarine (green shade) using the medium wash brush. Lift out an area for the building, using the rag.

2 Once dry, lay in a wash of yellow ochre using the size 6 brush, applying a dry-brush technique along the bottom of the paper. Mix lemon yellow with cobalt blue and use it to fill in the crowns of trees on the horizon line.

3 Darken the green mix with ultramarine (green shade), and use this to fill in the shadow details on the trees, wet-in-wet.

4 For the building, mix rose madder and yellow ochre into a terracotta pink. We will fill in the roof in a different, darker colour later, but begin by filling in the whole shape of the building. Use a damp rag to lift out the colour from the body of the building where the midground hay bale will sit.

5 Mix lemon yellow and sap green for a yellow-green, and fill in the top edge of the field. Dry-brush the colour downwards, then lift out areas for the hay bales, using the rag.

6 Reinforce the darks on the trees using the green mix from step 3. Then lay in the tree trunks in yellow ochre.

7 Use the yellow ochre to define the edges of both hay bales in front of the house, then to define their cylindrical shape. Fill in the bales with a weaker wash of the ochre, leaving some light areas on the tops of the bales. Allow to dry.

8 Lay in the rooftops in a mix of rose madder, ultramarine and a touch of sap green. Use the same mix to fill in the tree trunks in front of the buildings, to enhance the grass line and the shadowed areas at the base of the hay bales. Once dry, use the mix to fill in the dark furrows in the foreground of the field before going back over the rooftops and tree trunks to add value to the areas. Do the same to the dark areas on the bales and allow to dry once more.

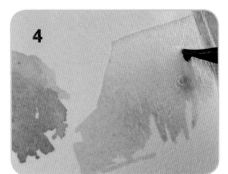

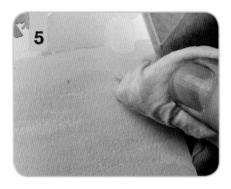

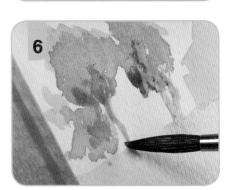

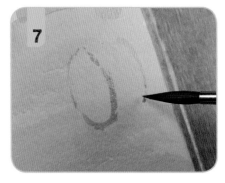

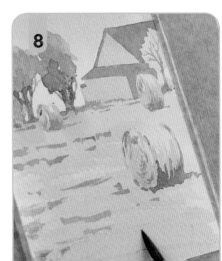

9 Glaze over the purple-grey areas to give the roofs of the building more definition, then drop in a cadmium red and cadmium yellow mix on the side of the building.

10 Use sap green to fill in the crown of the the right-hand tree, in front of the buildings.

11 Load your brush with cadmium yellow again: lay the wash over the lawn area as a glaze. Go into the bales with the cadmium yellow, then allow to dry.

12 Fill in the shadows of the roofs and eaves of the buildings with ultramarine (green shade), then the shadows of the trees and hay bales. Soften the shadows with the damp rag; then, to finish, drop in shadows in the furrows of the field.

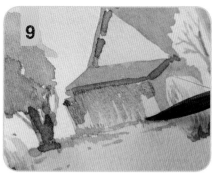

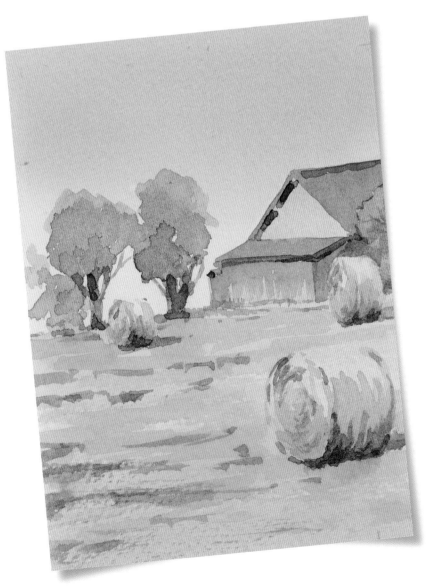

Distant buildings

As you paint a landscape, it is essential that you are able to create a visual sense of depth through your brushstrokes, colour choices and composition. When you include distant buildings in a landscape, ensure that you allow them to blend tonally with the surrounding hedgerows, trees and so on. Suggest – rather than record – detail when painting buildings into a landscape.

YOU WILL NEED

Paint colours: cobalt blue, rose madder, sap green, lemon yellow, ultramarine (green shade), burnt sienna, cadmium red, cadmium yellow

Brushes: medium wash brush, size 6 round brush

Other: rag, masking fluid and applicator, tracing number 29

1 Lay a flat wash in cobalt blue with the wash brush. Lift out the clouds with a damp rag, then soften the bottom of the sky line with the rag.

2 While the sky is still damp, take up a mix of rose madder and cobalt blue on the size 6; lay in the colour where the distant hills are going to be. Soften off the bottom of the rose madder and cobalt blue area with the rag.

3 Go back to the cobalt blue (with a touch of rose madder mixed in) to draw in more of the backdrop to the landscape. Dot in some darker areas to define the horizon, then allow to dry.

4 Use dots of masking fluid to create the areas where the buildings will be, representing the overall shapes of the buildings at this stage. Allow the masking fluid to dry.

5 Soften the distant mountains with the damp rag.

6 Load the size 6 with sap green. Dot the green behind and around the masked-out buildings, all the way across the paper. Lay in opposing lines of hedgerows in the foreground. Allow to dry.

7 Make up a weak mix of ultramarine (green shade), rose madder and sap green; drop in some darker details along the lines of mountains in the distance. Make up a stronger mix for the base of the hills. Allow to dry.

8 Use cobalt blue to fill in the area of water at the foot of the hills and soften the area with a damp rag.

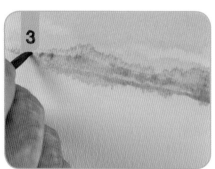

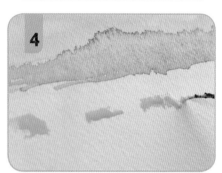

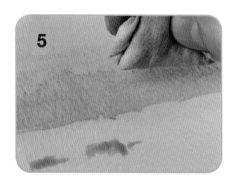

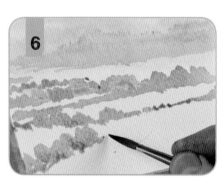

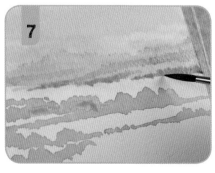

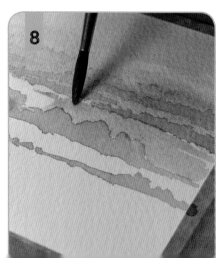

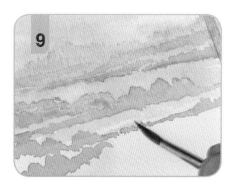

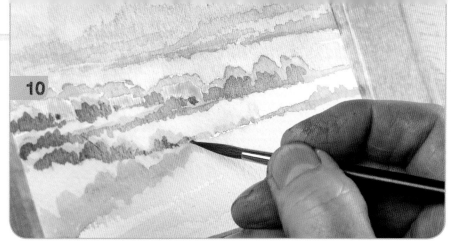

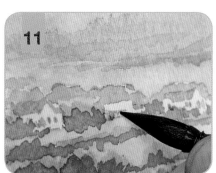

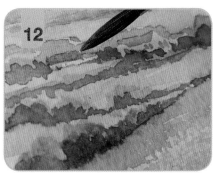

9 Use a mix of sap green and lemon yellow to fill in the foreground fields, using a dry-brush technique.

10 Use a mix of ultramarine (green shade) and sap green to dot in the trees at the front of each of the hedgerow areas, and in front of the buildings. Add more ultramarine to the mix for the foreground bushes and soften with a damp brush. Allow to dry.

11 Rub off the masking fluid. Then, with a mix of ultramarine, rose madder and a touch of sap gren, fill in the colours and details of the distant buildings. Allow to dry.

12 Lay in a weak wash of burnt sienna across the foreground field, in a dry-brush effect, to suggest texture and add interest. Finally, mix cadmium red and cadmium yellow, and fill in the top of the middle building in the landscape to draw in the eye.

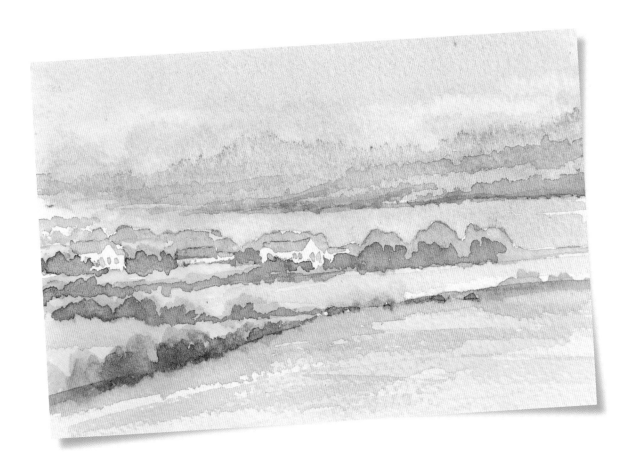

YOU WILL NEED

Paint colours: cadmium yellow, cadmium red, ultramarine (green shade), rose madder, sap green, cobalt blue

Brushes: small and medium wash brushes, sizes 2 and 4 round, rigger, filbert, toothbrush, hog-hair bristle brush (stiff brush)

Other: rag, tracing number 30

The urban landscape

Street scenes, as with pastoral scenes, can be dynamic and full of interest, with plenty of opportunity to use colour and light. The moody urban atmosphere of this scene is created in the first instance by laying a series of flat washes across the paper.

1 Begin with a cadmium yellow wash on a small wash brush, coming in from the right. Overlay this with cadmium red, working wet-on-dry from the opposite edge of the paper. Mix the two where the colours meet. Next, lay in a vertical wash in ultramarine (green shade) starting from the left edge. Allow to dry, then glaze over with a wet-in-wet wash of reds and blues from your palette on the right of the paper. Allow to dry again.

2 Rewet your paper, then lay a horizontal wash of rose madder on a medium wash brush. Work to a quarter of the way down the paper, then repeat from the bottom of the paper to a quarter of the way up. Load the brush with ultramarine (green shade), and go back over the rose madder strokes from both ends of the paper, meeting in the middle. Allow to dry.

3 Suggest the shapes of two buildings on either side of a narrow road with weak ultramarine (green shade). Define their edges with a darker wash of ultramarine on a rigger. Lay a shadow down the middle of the road, imagining a street light in the centre of the scene. Soften the shadows with a damp rag.

4 In a pale ultramarine wash, dab and twist in the foliage of a tree appearing between the right-hand buildings, using a filbert. Mix the ultramarine with rose madder and paint in the recessed doorways of the foreground buildings with a size 2 round brush.

5 With the same weak ultramarine-rose madder mix, paint in a street light coming from the wall of the right-hand foreground building. Grey this mix with a hint of sap green, then suggest a figure in the background.

6 Sweep weak cobalt blue in horizontal strokes across the road to suggest the shadows of the buildings, then lay a graded wash of ultramarine (green shade) and rose madder from the top to the bottom of the paper until the background is softened. Rotate your paper 180 degrees and repeat from the bottom to the top. Dab with a damp rag to soften, then grey the whole scene with a flat wash of sap green.

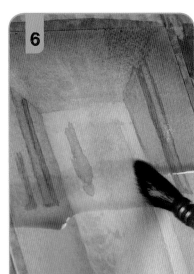

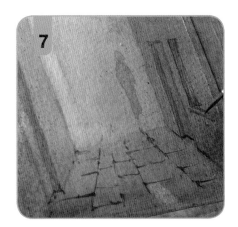

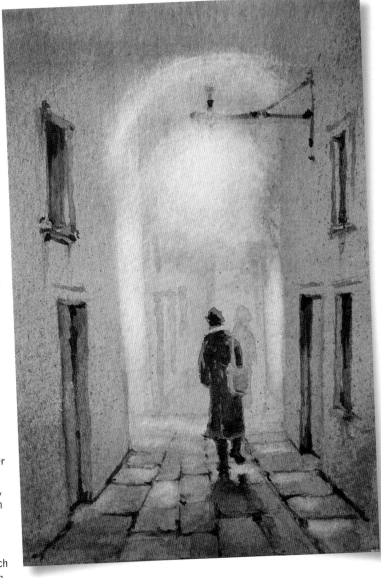

7 With a toothbrush, flick a mix of rose madder, ultramarine (green shade) and sap green over the walls and the road for texture. Define the pavements and some paving stones in cadmium red and sap green on a size 2 round brush; use the same mix to define the windows and doorways. Further reinforce the darker areas with ultramarine, rose madder and sap green. Then use a stiff brush, dampened, to lift out some light areas along the pathway to suggest a kerb and individual slabs.

8 Glaze over the slabs with cadmium red in the foreground, and cadmium yellow into the background. Use cobalt blue to dab and twist over the foliage and to suggest windows and doors on the rearmost buildings, using the size 4 round.

9 Fill in the walking figure in a mix of rose madder and ultramarine (green shade); leave an area of negative space for her bag. Lay in her shadow in the same purple mix, then allow to dry. Dot in cadmium yellow in the negative space for her shoulder bag, then grey the yellow with ultramarine, rose madder and sap green to define it.

10 Lift out the area of light from the street light fixture with a damp rag; begin with a circle, then lift out a halo of light in an arch over the top of the fixture. To finish the scene, fill in the shadow on the foreground figure in a strong, dark mix of rose madder, ultramarine and sap green on the size 2 round, working from the left. Do the same to the woman's shadow, then enhance all the other dark areas in the scene in the same mix.

COUNTRY COTTAGE

See tracing number 31

The initial graded wash of cobalt blue was allowed to dry, then using a size 2 round brush, the distant trees and foliage were painted with a mix of cobalt blue and a touch of rose madder. Using a small wash brush, a pale wash of yellow ochre was painted over the entire cottage shape, path and surrounding bushes and allowed to dry.

The tree shapes in the background behind the cottage were painted with a size 4 round brush using a mix of ultramarine (green shade), rose madder and sap green. The darker parts of the trees were painted with a more intense mix of the same colour mix. The foliage for these trees was created using firstly pale cobalt blue, followed by sap green mixed with cobalt blue, and then sap green mixed with lemon yellow, all using the dab and twist technique with a small filbert brush. The twigs and branches were enhanced with a mix of ultramarine (green shade), rose madder and sap green.

Parts of the roof and sections of the front of the cottage were glazed with rose madder and cobalt blue. The details on the cottage were established using a mix of ultramarine (green shade), rose madder and sap green. The foliage at the front of the cottage, grass and the foreground bushes were created using, initially, a wash mix of sap green and lemon yellow over the larger shapes, followed by the darker shapes and details which were created using a more intense mix of ultramarine (green shade), rose madder and sap green.

The flowerbeds were dabbed in using the following colours: rose madder, cadmium yellow and sap green, to represent a variety of flowers. The path A wash of rose madder was applied over the lower part of the path, and then dry-brushed, with a mix of ultramarine (green shade), rose madder and sap green painted over the lower part of the path. A few spots of a very intense mix of ultramarine (green shade), rose madder and sap green were applied over areas of the path and the bushes. Sandpaper and a craft knife were used to create light on the foliage of the bushes, and the loose pigment removed with a putty eraser.

Notice how the same colours are used repeatedly throughout the picture in different areas, to bring harmony to the scene.

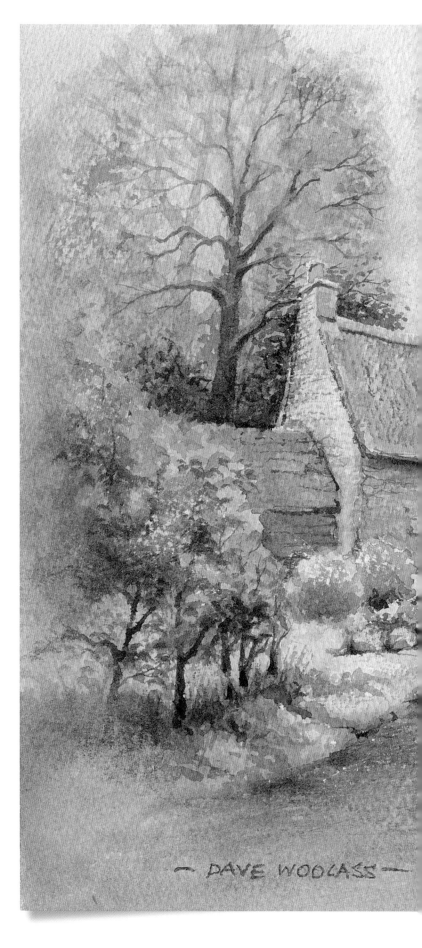

— DAVE WOOLASS —

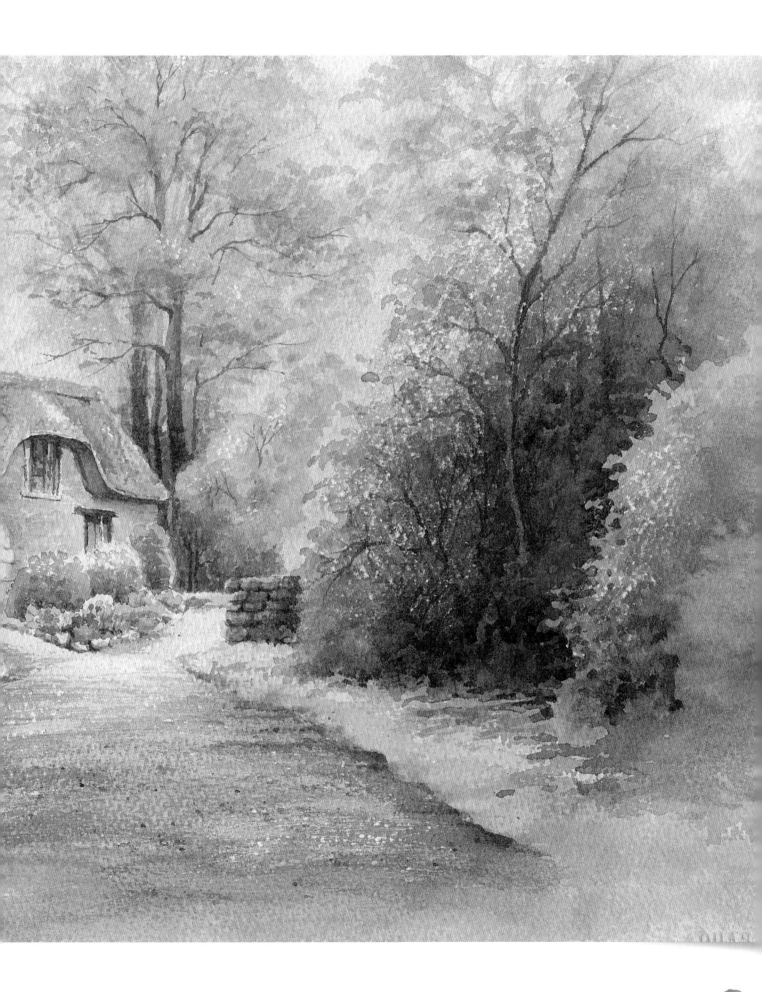

BOATS ON A LAKE

See tracing number 32

The initial graded wash in cobalt blue was applied with a large wash brush and allowed to dry.

Using a size 4 round brush, the distant hills were painted in a mix of cobalt blue, a touch of rose madder and a touch of sap green. The hills in the midground were painted in a slightly more intense mix of this colour and the details created using a further, more intense, mix of these same colours.

When completely dry, a colour shaper was used to apply masking fluid in order to preserve the sparkles on the water. Next, a toothbrush was used to splatter the masking fluid into the water area of the picture, working from the horizon towards the foreground.

After the masking fluid had dried, a wash of cobalt blue with a touch of sap green was added over the entire area of the water, using a larger wash brush. Once dry, a more intense mix of the same colours – with a touch of rose madder added – was used to paint in the ripples and the surface of the water. When the paint was completely dry, I used my forefinger to rub away the masking fluid.

The shapes of the boats were painted in using an intense mix of cobalt blue with a touch of rose madder and a touch of sap green. The detailed shapes and shadows of the masts and so on were added at a later point.

When the whole scene had dried, the highlights on the water were enhanced with a craft knife to scratch out smaller areas. The putty eraser was used to remove the loose pigment and brighten the highlights.

AUTUMN WALK

See tracing number 33

Using the large wash brush, a graded wash of cobalt blue was applied for the sky. The background tree shapes were established in a mix of yellow ochre, cobalt blue and a touch of rose madder, using a size 4 round brush. The tree trunks and branches were painted with a mix of cobalt blue and rose madder, greyed with a touch of cadmium yellow, using a size 2 rigger.

A pale wash of cadmium yellow was laid with a large wash brush into the shapes of the left-hand trees and bushes. The path and the right-hand side ground area and bushes were washed in with the same colour. Using the dab and twist technique with the filbert brush, a light cadmium yellow wash was added to represent light within the large tree foliage and on both the left and right sides, as well as the colour of the leaves on the ground. A light mix of rose madder using the dab and twist technique was used to create the lighter red foliage within the trees, bushes and fallen leaves.

A dry-brush effect, with this same colour, was applied to the path, with the pigment made to appear lighter as the path recedes. When the paint was completely dry, masking fluid was applied using a colour shaper over the light-coloured areas, in the shapes of leaves, to preserve light areas within the final painting. This was left to dry.

A further glaze of cobalt blue was applied using a small wash brush, in the bases of the trees and on the ground, and to paint the negative shapes of the lighter areas within the bushes. This was enhanced with a glaze of sap green. Using the dab and twist technique, the foliage in the trees and bushes, along with some on the ground, were painted in sap green. The size 2 rigger was used to apply a mix of cobalt blue, rose madder and a touch of cadmium yellow to the midground branches and twigs. The main trunk and branches were established in the same mix. Using a stronger mix, the darker twigs and branches in the bushes along with the branches and twigs of the main tree were painted, as were the darker foliage areas and shapes on the ground, using a size 2 round brush.

The figure and the dog were painted in a mix of cobalt blue, rose madder and a touch of sap green; a weaker mix was used for their shadows. The final darks and details on the twigs and branches were painted using a stronger mix of these colours. Final highlights were achieved using the craft knife.

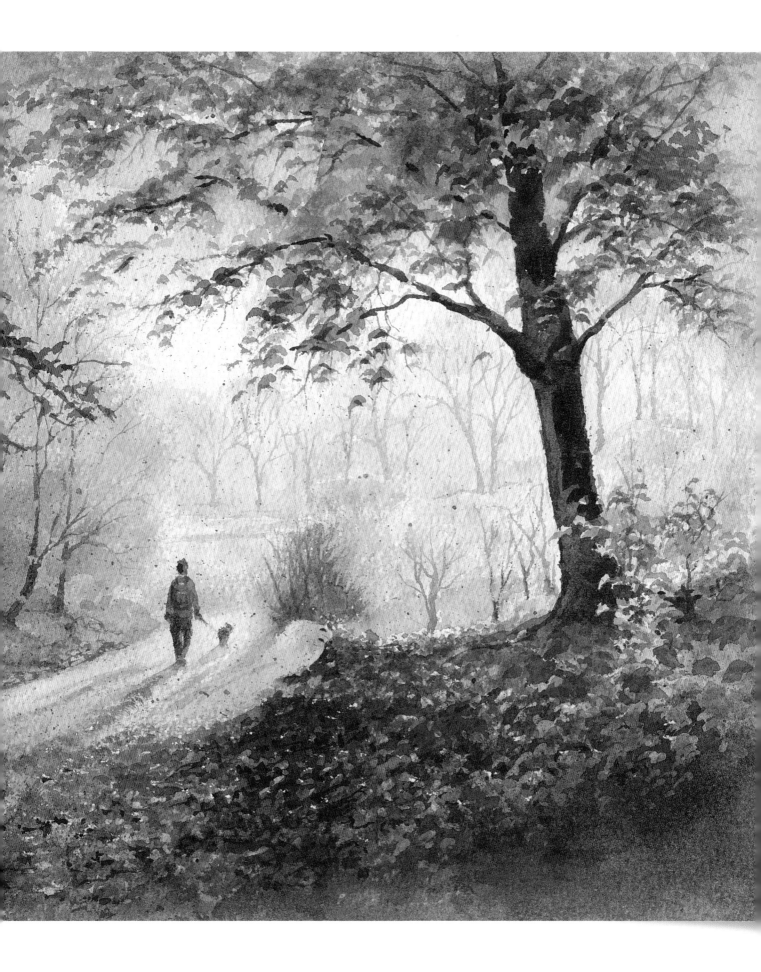

INDEX